IMAGES
of America

APACHE JUNCTION
AND THE
SUPERSTITION MOUNTAINS

ON THE COVER: On March 18, 1911, several vehicles festooned with flags and red, white, and blue bunting made their way along the Apache Trail for the dedication of the Roosevelt Dam. To accommodate visitors to Arizona's newest tourist attraction, a 16-foot-wide road for automobiles crossed the top of the dam. In 1901, president-elect Theodore Roosevelt, who loved the West, allied himself with those in favor of irrigation. On June 17, 1902, Congress passed the National Reclamation Act, which combined executive independence from Congress, nationalization, and a scientific approach to natural resource management. (Courtesy Salt River Project.)

IMAGES
of America

APACHE JUNCTION
AND THE
SUPERSTITION MOUNTAINS

Jane Eppinga

ARCADIA
PUBLISHING

Published by Arcadia Publishing
Charleston SC, Chicago IL, Portsmouth NH, San Francisco CA

Printed in the United States of America

Library of Congress Catalog Card Number: 2005932495

For all general information contact Arcadia Publishing at:
Telephone 843-853-2070
Fax 843-853-0044
E-mail sales@arcadiapublishing.com
For customer service and orders:
Toll-Free 1-888-313-2665

Visit us on the Internet at www.arcadiapublishing.com

CONTENTS

ACKNOWLEDGMENTS

Creating a book is never entirely the work of one person, and so it is with *Apache Junction and the Superstition Mountains*. The book would never be produced without the wonderful records and photographs of the Superstition Mountain Historical Museum. Gregory Davis, who is in charge of acquisitions and research for the museum, has collected most of the documentation and photographs in this book and provided guidance through the labyrinth of materials. Laurie Devine provided assistance by supplying pictures from the Arizona State Archives. Shirley Keeton, executive director, and George Johnston, president of the Superstition Mountain Historical Society, provided assistance on the book. Among the many authors who have left their mark on the Superstition Mountains and this book are Clay Worst, Jack San Felice, Larry Hedrick, Gregory Davis, Helen Corbin, Estee Conaster, James Swanson, Thomas Kollenborn, and T. E. Glover. Kollenborn has provided excellent timelines for sorting out the area's history. Shelly Dudley spent time with the author and provided help in both securing images of the Salt River and freely sharing knowledge from her long association with the Salt River Project. Organizations that have contributed to this work include the National Archives Washington, D.C., the Library of Congress, Arizona State Archives, the Arizona Historical Society, and the Salt River Project. No book ever sees the light of day without a publisher and an editor such as Arcadia and Christine Talbot and the Arcadia staff. Finally, the biggest contributors are those pioneers who left their stories on Apache Junction and the Superstition Mountains, particularly Dutch seekers (slang for Lost Dutchman Mine seekers) such as Sims Ely and Barry Storm. And then there is the Dutchman himself, who took his secret to his grave.

INTRODUCTION

Tom Kollenborn has described the Superstition Mountains as a ride through time. Indeed, if one takes the time to listen to the silence, perhaps he or she might hear the cries of those who lost the lives in the quest for gold. Perhaps a person might hear the ancient thunder gods laughing as mere mortals seek to find where they have hidden the elusive gold. The story of Apache Junction and its people is essentially the story of the Lost Dutchman Mine, supposedly located in the Superstition Mountains east of Phoenix, Arizona.

In 1846, German immigrant Jacob Waltz came to the United States. After becoming a naturalized American citizen in 1861, he traveled to Arizona and became a prospector. Sometime between 1872 and 1878, Waltz and partner Jacob Wieser reportedly discovered an 18-inch-wide vein of gold. One day, while working on the mine, Wieser was killed by Apaches or perhaps by Waltz himself. Waltz concealed the mine entrance, took enough ore to live on, and moved to Phoenix.

Waltz delivered eggs to an African American woman, Julia Thomas, who owned a local bakery. When he discovered that Julia was in danger of losing her bakery, he offered to help repay her debts and showed her gold ore worth about $1,500. In 1891, Waltz's house was flooded when the normally dry Salt River was besieged with runoff from torrential rains. He caught pneumonia and died on October 25. Shortly before his death, he sketched a map for Julia of the mine's location. However, Julia and her friends were never able to find the mine.

This story has drawn treasure hunters from all over the world into the Superstitions. Some have died, often under mysterious and gruesome circumstances. For most searchers, greed replaced common sense. Many strange events have occurred deep within the recesses of the Superstition Mountains. Perhaps nowhere else in the Untied States is there an area as full of legend, history, and intrigue as this rugged mountain range in central Arizona. The lure of gold has haunted those who would sacrifice everything in their quest for instant wealth.

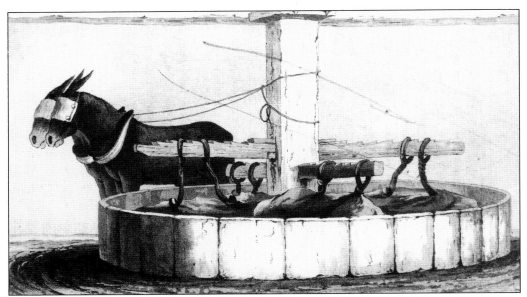

This is an early-19th-century drawing of an *arrastre* (Spanish grinding stone), used for one of the most primitive methods of mining. It was still in use in the Superstition Mountains in the 1950s.. (Courtesy Arizona Historical Society.)

This image of a primitive Mexican mining method was taken from Richard Hinton's 1978 *Handbook to Arizona.*

One

JACOB WALTZ AND THE SUPERSTITION MOUNTAINS

Jacob Waltz and his mine are forever linked to the Superstition Mountains of central Arizona. He arrived in Arizona after the California gold rush stopped. At the time, anyone prospecting in Arizona's mountains stood a good chance of finding an arrow in his back. Still, Waltz persevered and found success with mining. His name appears on a petition to the governor asking for protection against "Indian depredations" in 1865. Whatever the dangers, Waltz stayed. Julia Thomas cared for him in his later years until he died from pneumonia. His obituary appeared in the *Phoenix Daily Herald* of October 26, 1891, the day after his death. Although Jacob Waltz left such a legacy of mystery, there are many verifiable documents on the man.

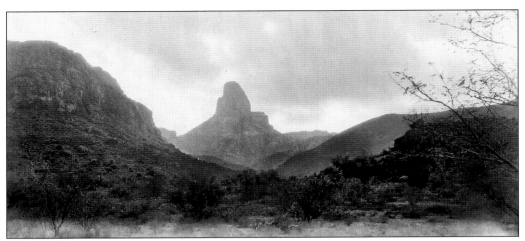

The roar of the thunder gods cascades down Weaver's Needle during a storm. This mountain may hold the key to the Lost Dutchman Mine. Waltz would tell riddles such as "from the tunnel of my mine I can see the Military Trail below, but from the Military Trail you cannot see the entrance to my mine." Soldier's Trail curves around Weaver's Needle. Many people tried to trail Waltz to his mine, but he managed to elude them all. (Courtesy Superstition Mountain Historical Society [SMHS].)

There are many photographs purporting to show Jacob Waltz, but none have ever been confirmed. He was described as having a white beard, so perhaps it may be this old prospector. By 1848, Waltz was in Natchez, Mississippi, where he formally declared his intention to become a naturalized United States citizen, before the gold rush in California lured him to the West. (Courtesy SMHS.)

Oren Arnold used this drawing to illustrate his book *Superstitions Gold*. Waltz is often described as "Old Snow beard" or the Dutchman. Although he had a white beard, he was not the grandfatherly type. He was a taciturn man with piercing eyes that frightened children. Waltz had a reputation for having killed several gold-seekers, but nothing was ever proven. (Courtesy SMHS.)

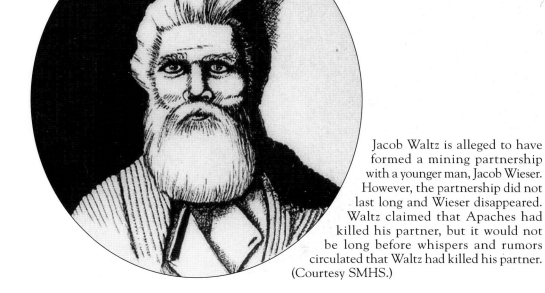

Jacob Waltz is alleged to have formed a mining partnership with a younger man, Jacob Wieser. However, the partnership did not last long and Wieser disappeared. Waltz claimed that Apaches had killed his partner, but it would not be long before whispers and rumors circulated that Waltz had killed his partner. (Courtesy SMHS.)

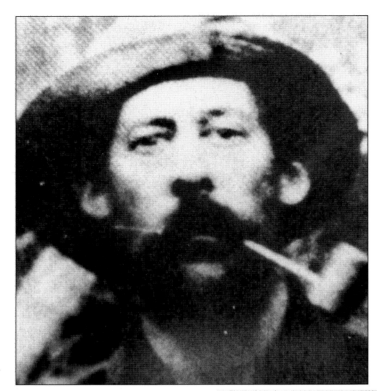

Robert Blair used this Jacob Waltz image in *Tales of the Superstitions*. Probably the only luxury Waltz had at this time was his pipe and a little tobacco. Sometime around March 1868 Waltz homesteaded 160 acres north of the Salt River, and today his land is part of the modern metropolitan Phoenix. It is bounded on the north by Buckeye Road, on the west by Seventh Street, on the east by Twelfth Street, and on the south by Interstate 10. Waltz tried to farm, but wanderlust kept calling him to the Superstition Mountains. (Courtesy SMHS.)

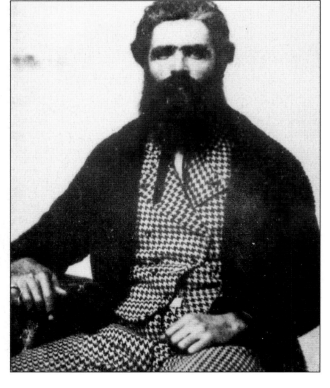

This Jacob Waltz image seems to be the favorite choice for the Lost Dutchman. Here he appears to be enjoying some prosperity. His farm was close to his cousins, the Starrars, and he had a home. The 1872 tax rolls show him as a man with a couple of horses or mules, and his property was worth $200, a considerable sum in those days. (Courtesy SMHS.)

Then, as so often happens with mining men, life took a turn for worse for Waltz. His health began to fail in 1878. He deeded over his property to cousin Andrew Starrar with the stipulation that Starrar would care for him as a member of the family for the rest of his life. Evidently, Waltz thought he was dying, but he recovered and outlived Starrar by several years. (Courtesy SMHS.)

The Petrasch family arrived from Prussia in 1868. They settled first in New York and then began a westward migration that took them to Kansas and ultimately to Phoenix. The father ended up in the Arizona State Insane Asylum. Upon their arrival in Arizona, they bought five family plots in the Phoenix Cemetery, and one was ultimately sold to Jacob Waltz. From his homestead, Herman Petrasch could see the Superstition Mountains with its secrets. (Courtesy SMHS.)

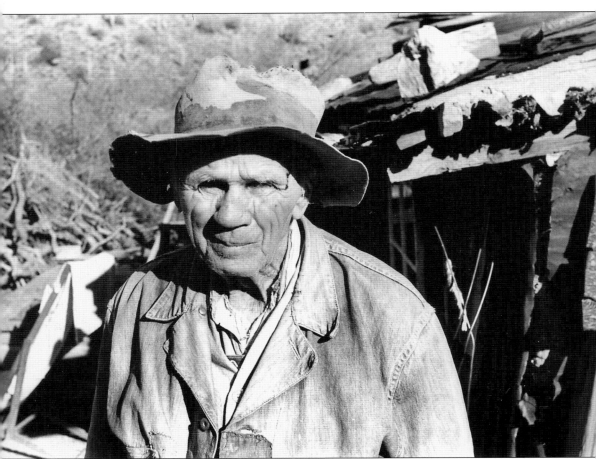

Herman Petrasch tried to help Julia Thomas, who cared for Waltz in his last days, find the mine, but the effort was in vain. Herman worked as ranch cook, but he never liked to ride horses. As he grew older, he became obsessed with finding Waltz's mine. He claimed to have dug up a pot of gold from under the fireplace chimney where Waltz's house once stood. (Courtesy SMHS.)

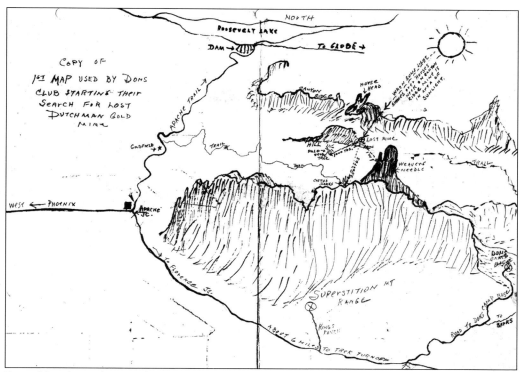

For gold seekers, there is always one document of extreme importance—the map. In the case of the Lost Dutchman Mine, there are many maps, some of which are inscribed in stone. This is the map used by the Dons, a group of young men who organized in 1934 to explore the desert to search for the Lost Dutchman Mine. The *Los Angeles Examiner* wrote that it was as if they tried to do en masse what individual prospectors had failed to do. They were no more successful than anyone else, but the Trek of the Dons became an important force in preserving Superstition Mountain history. (Courtesy SMHS.)

Julia Thomas, an African American woman who ran a bakery and cared for Jacob Waltz in his final hours, supposedly received this map, which is a facsimile of the original. Shortly after Waltz's death, Thomas began selling copies of the map. No original Julia Thomas maps are known to exist today, though. It is curious that north is indicated at the bottom. In copying the maps, Thomas may have added bits from her memory. (Courtesy SMHS.)

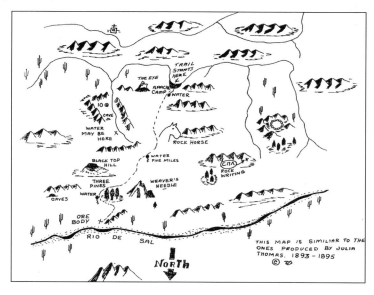

EN TO RICHARD HOLMES by JACOB WALTZ (tHE DUTCHMAN)
THE NIGHT OF OCTOBER 25, 1891, THE NIGHT WALTZ DIED.
WS EXACT LOCATION OF THE "LOST DUTCHMAN MINE".

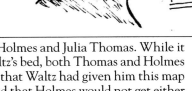

After Waltz's death, bad feelings developed between Richard Holmes and Julia Thomas. While it is not known exactly who received the gold stashed under Waltz's bed, both Thomas and Holmes began accusing each other of stealing it. Holmes also claimed that Waltz had given him this map on the night of his death. Julia, as possessor of the map, decided that Holmes would not get either the gold or the map. Neither one of them ever found the mine. Within two years after Waltz's death, Julia lost her business and savings. (Courtesy SMHS.)

Author Jack San Felice holds the heart stone. These stones, with their enigmatic inscriptions, have infected many treasure seekers with "stone mapitis." It is not even known for certain that the maps originated in Arizona, but most of the Dutchman hunters are quite content to let them be maps of the Superstition Mountains. Some say they were found in the fork of a tree near Florence Junction. Another claimed a cowboy found them while digging post holes. A few naysayers claim that they were concocted as a hoax by a cowboy known as Johnny Steel. (Courtesy SMHS.)

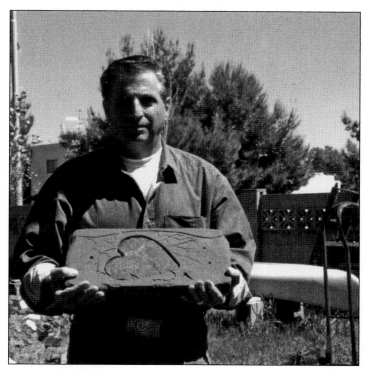

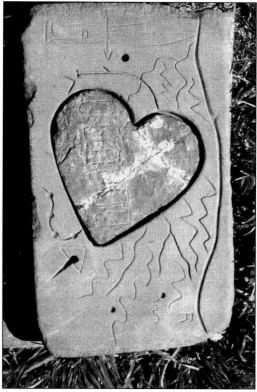

Travis Tumlinson from Oregon claimed to have found the stone maps. His brother, Robert Tumlinson, claimed that when Travis saw something jutting out of the earth, he returned to his vehicle, got a spade, and dug up the stones. Travis formed a partnership with Dr. Gene Davis, but within three years Travis lost interest in the search for the Dutchman Mine and dissolved the partnership. (Courtesy SMHS.)

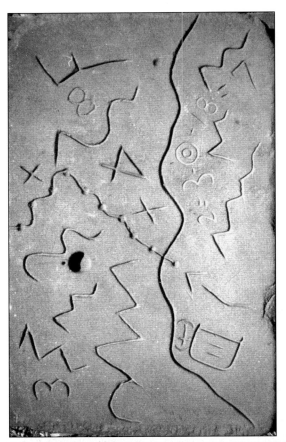

Travis Tumlinson returned to the area but never found any more stone maps. The reverse of the Priest Stone appears to be part of a larger map that no one has yet deciphered. The Superstition Mountain Historical Museum has a replica set of the Peralta Stone maps, but the originals are located in the Arizona Mining and Mineral Museum in downtown Phoenix. (Courtesy SMHS.)

The priest side of the Horse-Priest Stone map depicts a priest's figure on the left side of the stone. It reads, "This trail is dangerous. I go eighteen places. Search for a map. Search for the heart." (Courtesy SMHS.)

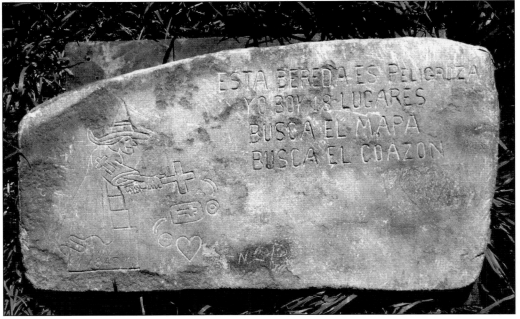

On the opposite side of the Cross Stone is one word, "Don," a Spanish title of respect for men. This stone stuck out of the ground and caught Tumlinson's attention. (Courtesy SMHS.)

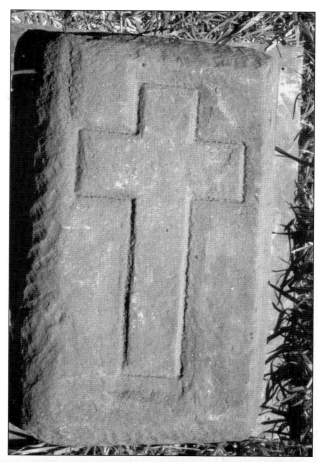

The horse side of the Priest-Horse stone translates to "The horse of Santa Fe I pasture to the north of the river." (Courtesy SMHS.)

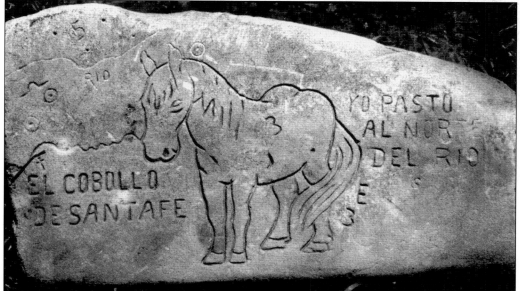

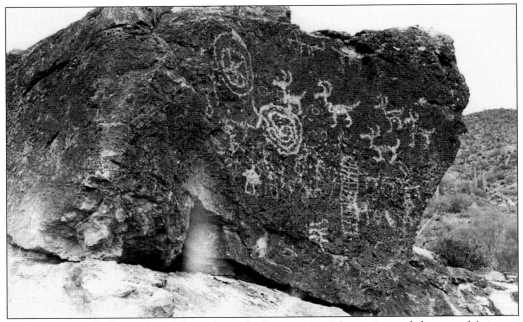

Primitive petroglyphs are found throughout the Superstition Mountains and the rest of Arizona. Ancient people may have used this art as a means of recording their history. The circles may have helped the Anasazi track the stars and the sun, or it may be a documentation of a hunting party. Perhaps this image may have been the "newspaper" of ancient people, but it is not known how to correctly interpret it. (Courtesy SMHS.)

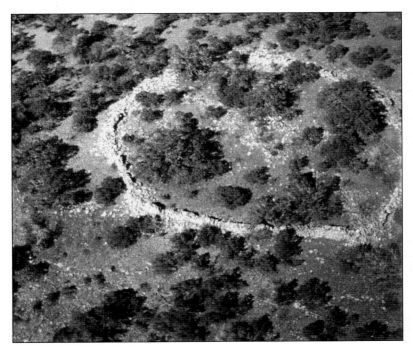

Tom Kollenborn played a key part in trying to unravel the mystery of the circle stones of the Tonto National Forest. The circle has a circumference of about 420 feet. Like the petroglyphs, the structure may be destined to fade into oblivion with its secrets unsolved. The meaning may not be understood, but it is a connection to the past. (Courtesy SMHS.)

The ancient people have left something of their everyday utensils, such as this lovely grinding stone. Early in the morning, the women would use such stones to grind wheat for their families. The presence of grinding stones may have come from a much older culture and may demonstrate that humans were adapting to the changing environment after the end of the ice age and the extinction of large mammals. (Courtesy SMHS.)

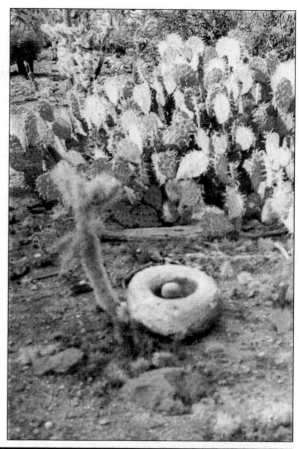

The ancient people who lived in this carefully crafted cliff dwelling might have heard the roar of the thunder god who, according to legend, preserves the secret of their gold treasure. They built the walls of fitted rocks and mortared them with mud. The structure stands as a tribute to an industrious people who have gone on before. (Courtesy SMHS.)

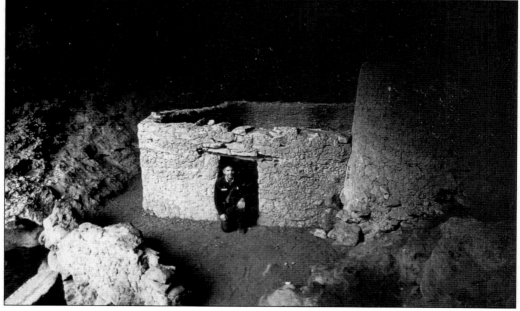

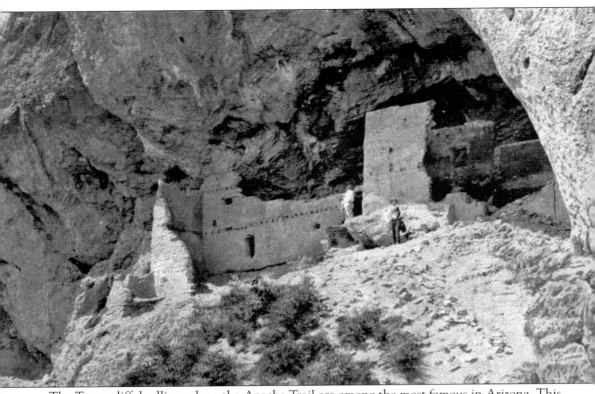

The Tonto cliff dwellings along the Apache Trail are among the most famous in Arizona. This well-preserved cliff dwelling was occupied by the Salado people from the 13th and 15th centuries. The Salado people farmed in the Salt River Valley and hunted and gathered native wildlife and plants. They produced beautiful polychrome pottery and intricately woven textiles. (Courtesy author.)

Two

CORONADO'S CHILDREN

In 1930, the Western writer J. Frank Dobie wrote *Coronado's Children*. In this first book, he described the tales and legends of those who searched for buried treasure in the Southwest, following in the footsteps of that earlier gold seeker, the Spaniard Coronado. Dobie wrote, "These people, no matter what language they speak, are truly Coronado's inheritors. . . . They follow Spanish trails, buffalo trails, cow trails, they dig where there are no trails; but oftener [*sic*] than they dig or prospect they just sit and tell stories of lost mines, of buried bullion by the jack load." These are the Coronado children of Arizona's Superstition Mountains. No matter that many of the writers were trying to capture the Dutchman's gold on paper for they most certainly would not have been averse to finding the gold itself. Truth be told, in a very real sense, everyone is part of Coronado's children. There isn't a person who wouldn't like to find fortune in some great mountain, and here are the some of the Lost Dutchman Mine seekers.

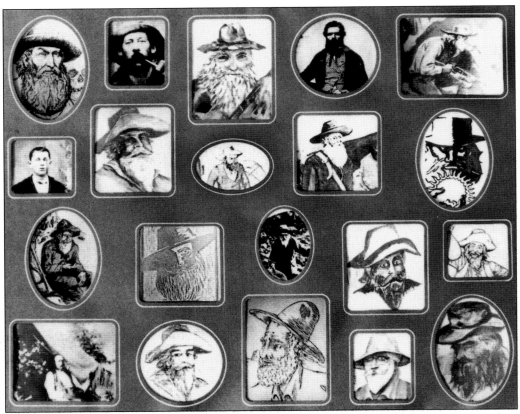

Although Jacob Waltz lived during the age of photography, his mine has not been found, nor his likeness positively identified. Somewhere in this montage of 20 images may be the real Jacob Waltz. (Courtesy SMHS.)

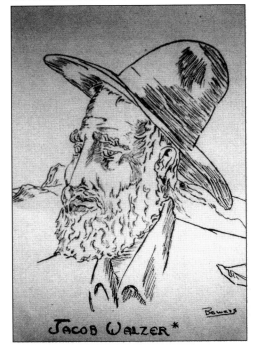

JACOB WALZER*

Although there are many spellings of the Dutchman's name, including Walzer as seen here, existing documents show that he signed his name as "Jacob Waltz," indicating he had a decent education in a day when probably few prospectors could either read or write. Born in Wurttemberg, Germany, in 1808, Jacob Waltz filed "Intention to become a Citizen" papers in Natchez, Mississippi, in 1861 and then began a long journey to the West. (Courtesy SMHS.)

Simon Novinger claimed to know Jacob Waltz. One day, a young Mexican boy appeared at Novinger's California farm saying that his family had been killed by Comanches. After working for Novinger for a while, the boy said he knew where there was a lot of gold and, with those words, left Novinger's employ to search for gold in Arizona. Before long, Novinger and another man were prospecting an area north of the Salt River when his shotgun accidentally went off and shattered his leg. After his partner deserted him, Novinger made his way to Fort McDowell where a doctor said his leg had to be amputated. Novinger refused the surgery and eventually the leg healed, but he always walked with a limp. Novinger gave up prospecting and established a successful hay farm in Arizona. (Courtesy SMHS.)

Mr. and Mrs. William (Laura) J. Middaugh of Joplin, Missouri, took a pack burro and a map the 59-year-old grandmother claimed had belonged to her great-great uncle Jacob Waltz on a 1947 trek into the Superstition Mountains in search of the Lost Dutchman Mine. They never found the gold. (Courtesy SMHS.)

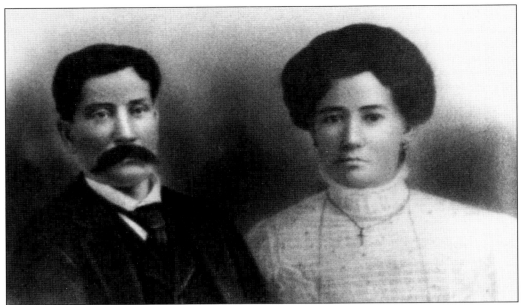

Jesus and Guadalupe Peralta were members of the large Peralta family that immigrated into Arizona in the late 1700s. They became associated with Superstition gold even before Jacob Waltz arrived. This prominent family from Sonora, Mexico, in lore, fled Mexico and survived an Apache massacre. They claimed that they mined the central Arizona Apache lands until they were attacked by Apaches and lost their gold. Several Peralta artifacts are on display at the Superstition Mountain Historical Society Museum, including old photographs. (Courtesy SMHS.)

Besides being a guide and author of books on the Superstition Mountains, Tom Kollenborn served for many years as the community schools director for the Apache Junction Unified School District. He has taught classes on the history of the Superstition Mountains for the high school district and Central Arizona College. His book *Superstition Mountain: A Ride through Time*, which he coauthored with Jim Swanson, is a classic history of the Lost Dutchman story. Kollenborn has also appeared in many television documentaries about the area. (Courtesy SMHS.)

Gregory Davis, a former navy officer, has collected Superstition Mountain history photographs and documents for almost 50 years. At present, he also flies cargo for a private airline company. Were it not for Greg's material, this book would not have been written because he has made it a cause to accumulate as many documents and photographs of the area as possible. (Courtesy SMHS.)

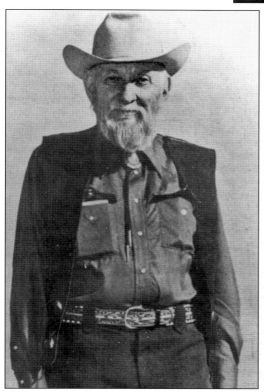

Frank Lowery was just one of the many interesting faces that appeared on the Lost Dutchman scene. Lowery, a columnist and newspaper man, wrote several articles on the Lost Dutchman Mine and played the Dutchman several times for Lost Dutchman Days at Apache Junction. (Courtesy SMHS.)

John D. Mitchell was not only a natty dresser for someone living in the Superstition Mountains, he was also a crack shot. According to his son, he killed a man in Alaska who misjudged him. Mitchell belonged to mining and railroad industries and knew many of the original Dutchman seekers, including Julia Thomas and the Petrasch family. In the early 1930s, he searched out the legends for his books *Lost Mines and Buried Treasure Along the Old Frontier* and *Lost Mines of the Great Southwest*. (Courtesy SMHS.)

Turner Helm also recorded the lore of lost gold mines in the Superstition Mountains. (Courtesy SMHS.)

Clay Worst has been exploring the Superstition Mountains and searching for the Lost Dutchman Mine for almost 70 years. At the age of seven, he reluctantly followed in the footsteps of his father when the family wintered in Arizona and his father became interested in the Lost Dutchman Mine. Worst is the author of many articles and a respected researcher. He has served as president of the Superstition Mountain Historical Society and is a member of the board. (Courtesy SMHS.)

Novelist, journalist, and Dutchman seeker Oren Arnold was born July 20, 1900, in Minden, Texas. He attended Rice University, where he served as editor of the student newspaper and was the Rice correspondent for the *Houston Chronicle*. Arnold worked briefly in the 1920s as a newspaper reporter and editor in Texas and Arizona, with successful freelance efforts, especially his Lost Dutchman writings. In 1934, he served as the first president of the Phoenix Dons, a group that has done much to popularize and preserve the Lost Dutchman lore. (Courtesy SMHS.)

John Clemenson (a.k.a. Barry Storm) would become one of the most popular authors with his book *Thunder Gods Gold*. It became the basis for the movie *Lust for Gold*, starring Glenn Ford and Ida Lupino. Storm interviewed many pioneers. He also filed claims on the Mother Lode Mine in September 1937 and on Superstition No. 1 on March 17, 1943. Storm believed that the Lost Dutchman Mine was near Weaver's Needle. (Courtesy SMHS.)

Beatrice Lewis married Alfred Strong Lewis, a geologist and mining engineer. Al had assessed the Goldfield Mine, and after his death Beatrice told the story that he found an old 60-foot-deep Spanish mine shaft on the Goldfield property. The Lewises never found the gold either. (Courtesy SMHS.)

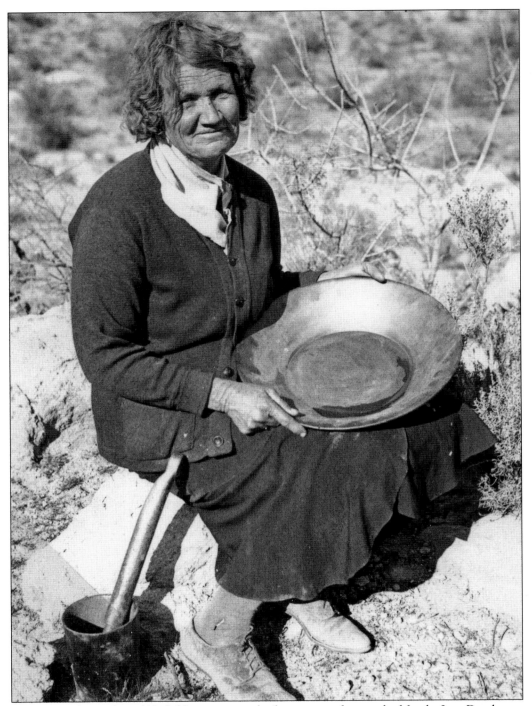

Sina Lewis, the mother of 13 children, was one the few women who searched for the Lost Dutchman Mine, and she did it for more than 20 years. When Sina was 68 years old, her son died and she met Ludwig Rosecrans, whom she persuaded to file on her son's claim. The pair became good friends but never found the Dutchman's gold. (Courtesy SMHS.)

Olive Stokes and her husband searched for the Lost Dutchman Mine for many years. (Courtesy SMHS.)

Milton Rose told the story of the Lost German Mine in his manuscript *Golden Rainbows*. It appears to have been a duplicate of the Lost Dutchman Mine. He also prepared a theoretical account of Jacob Waltz's death and postulated that the Dutchman's gold was in the Four Peaks area. Evidently, some people paid as much as $2.50 to view Waltz's body. (Courtesy SMHS.)

The solitary prospector and his burro heading out in search of gold was the image of western mining. He depended on his mule or donkey for carrying his equipment, transportation, companionship, and general safety. The main influx of donkeys into the western United States came with the gold rushes of the 19th century, and the solitary prospector and his donkey became a symbol of the Old West. Donkeys also carried water, supplies, and machinery to the mines, and hauled ore and rock out. Many of these animals grew up, lived, and died in the underground mines without ever seeing the light of day. They brought sacks of ore to the mills, where other donkeys turned the mills that ground the ore. With the coming of the railroad into the West, the use of the burro came to an end. With the coming of electricity and the railroad, these animals were turned loose. Free-roaming burros remain in the West. (Courtesy author.)

Ludwig "Doc" Rosecrans, born in Washington, hustled pool, panned for gold in California, and had a part as a Burundian soldier in the 1938 movie *If I were King*, starring Ronald Coleman and Claire Trevor. He attended college but had no interest in the academe, and he spent almost three years as a public relations writer for the army. Rosecrans arrived in the Superstitions in 1946 to get rich. He lived on the edge of poverty but became the resident philosopher. In the end, the killer mountains took their toll on his mind. (Courtesy SMHS.)

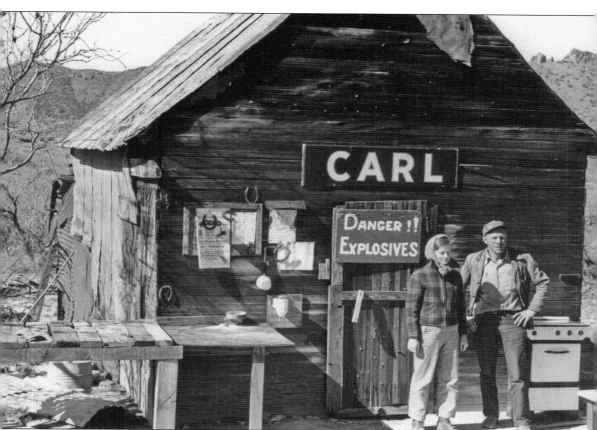

Carl Carlson and his girlfriend had a unique method of protecting their property in the Superstitions. They simply put up a sign, reading, "Danger! Explosives." (Courtesy SMHS.)

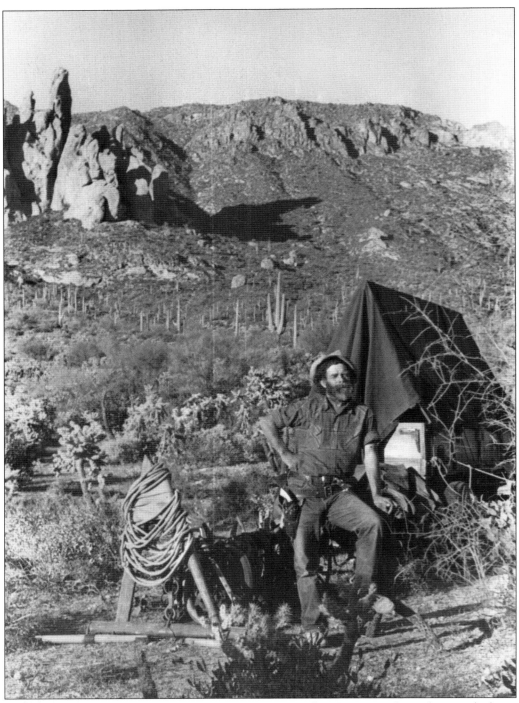

Cecil Stewart surveys his camp just east of Weaver's Needle. He was tough on the outside, but a hopeless dreamer on the inside. (Courtesy SMHS.)

Carl Broderick holds a silver ingot that he said came from the area around the Lewis claim, near Government Wells, on the Apache Trail. (Courtesy of Greg Davis.)

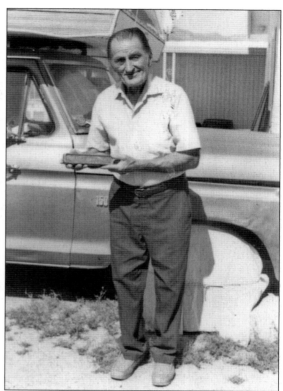

As early as 1934, the Superstition Mountain Historical Society was aware of its importance in Arizona history. Today, the museum continues to collect, preserve, and display the artifacts, history, and folklore of the Superstition Mountains, Apache Junction, and the surrounding region. Perhaps nowhere else in the United States is there an area as saturated with legend, history, and intrigue as the rugged 160,000-acre Superstition Mountains, which holds archeological evidence indicating people were here some 9,000 years ago. Later inhabitants included the Salado, Hohokam, and Apache people, followed by explorers and gold miners, trappers, cattlemen, and farmers. (Courtesy Arizona State Library, Archives and Public Records.)

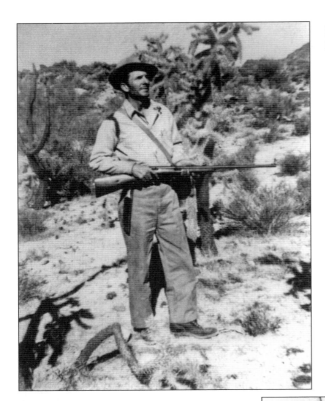

Desmond Sipes was a well-armed Dutch hunter. (Courtesy SMHS.)

Kraig Roberts met many of the interesting characters of the Superstitions when as a youth he roamed the mountains with his father William E. Roberts and a man named Edwards. They too followed the endless labyrinth of canyons in search of the elusive Dutchman's gold. (Courtesy of Greg Davis.)

Frederick Rawson is a typical reenactor of the famous gold-seeking days. (Courtesy of Greg Davis.)

John Reed was known among the Dutch hunters for always wearing two, and sometimes three, pair of pants. He was described as "built like an ox but carried not an ounce of fat on his body." In an article by Clay Worst, Reed supposedly told the Barkleys that between 1881 and 1888 his father had taken him to the Lost Dutchman Mine on three occasions and that twice they had "a hostile encounter" with Waltz. However, like the other Dutch seekers, he would never find the gold. (Courtesy SMHS.)

Lester "Jake" Miller prospected for gold in the Superstition Mountains. (Courtesy SMHS.)

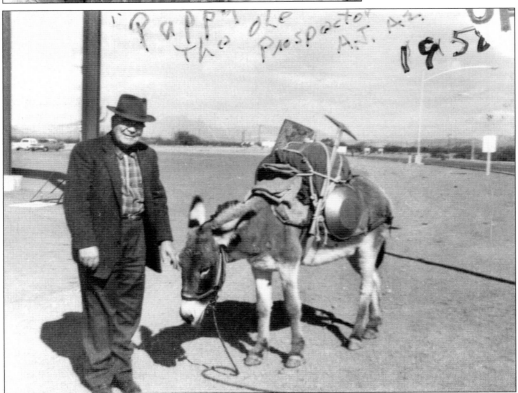

An old prospector, known only as Pappy, was one of the last of his breed to come into Apache Junction. (Courtesy SMHS.)

Three

MINERS AND MADMEN

The Lost Dutchman has sent out the siren call and lured many to the Superstition Mountains, where they killed or were murdered for gold. The Adolph Ruth murder became the most famous killing, but by no means was the only one. Many found a lonely canyon grave when what they really wanted was a mountain of gold nuggets. At the Superstition Mountain Historical Museum stands a monument with a prospector and his burro. The inscription reads as follows:

> Here lie the remains of Snowbeard, the Dutchman, who in this mountain shot three men to steal a rich gold mine from Spanish pioneers, killed eight more to hold its treasure, then died in 1892 without revealing its location. Dozens of searchers have met mysterious death in the canyons there, yet the ore lies unrevealed. Indians say this is the curse of the thunder gods on white men in whom the craving for gold is strong. Beware lest you too succumb to the lure of the Lost Dutchman Mine in Superstition Mountain.

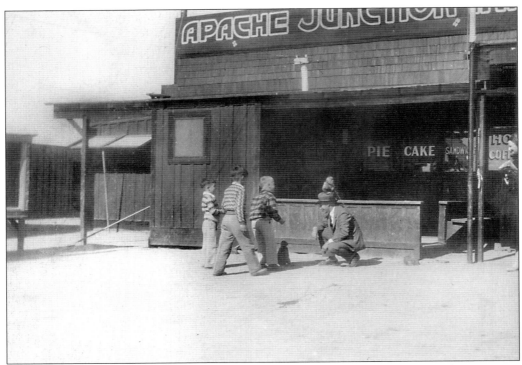

This photograph of a c. 1927 street scene in Apache Junction was taken by John Healy. The town derived its name from its location on the Apache Trail to Roosevelt at the junction with Superior Highway. It started as a group of gasoline and eating stations, with an interesting menagerie of local wild animals. (Courtesy Arizona State Library, Archives and Public Records.)

It would be hard to find a more malevolent character than Robert Simpson Jacob (a.k.a. Crazy Jake), who claimed to have found the Lost Dutchman Mine. Crazy Jake's list of crimes included fraudulent mining securities, prostitution and white slavery, pornography, narcotics, extortion, animal cruelty, and income tax evasion. Many prominent Arizonans invested thousands of dollars in his fake company. He would take an amount of $50,000 from them, but then the investors would claim a tax credit for $500,000, which put them in no position to report him to the authorities. Crazy Jake said he could not just dump his gold on the market, so he took it to Switzerland via Mexico, and for that he constantly needed more money. Once he got the gold to Switzerland, he would enlist the services of an organization big enough to handle a large amount of gold—the Vatican. (Courtesy SMHS.)

On August 15, 1986, before Crazy Jake went to trial, he pled guilty and agreed to make restitution to two victims. Many of those he defrauded still believed in him and refused to testify. He was released on parole on June 24, 1990, on the condition that he would repay $100,000. When he did not make restitution, his parole was revoked in 1993. In April of 1993, he was again released on a temporary release because of his failing health. He died shortly afterwards. Crazy Jake, a petty thief from Virginia, shaved his head and kept his false teeth in his shirt pocket. (Courtesy SMHS.)

In the 1950s, a war broke out between two camps in the Superstition Mountains. Both the Piper Camp and the Jones Camp were searching for what they thought was the Lost Jesuit treasure that the Dutchman had found. Legend has it that when the Jesuits were expelled from Spain's new world colonies in 1767, they hid hundreds of mule-loads of treasure in the Superstition Mountains. The feuding was deep and gunfire was not long in coming. A bar owner in Apache Junction put up two signs, reading, "Enlist here for Ed Piper's Army" and "Enlist here for Celeste Jones' Army." Several armed men arrived, eager to be a part of the last of the Wild West's gunfights. These are members of Celeste Jones's army. (Courtesy SMHS.)

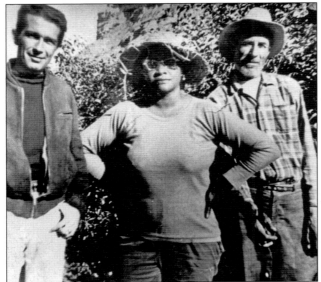

Celeste Marie Jones poses with former Arizona attorney general Robert Corbin and one of her soldiers, Louis Roussett, at her camp in East Boulder Canyon at the foot of Weavers Needle. During the war, Jones was accused of hiring Robert St. Marie to kill the colorful prospector, Ed Piper. Jones, a large African American woman, may have been an opera singer in the Los Angeles area. Corbin was himself an avid Dutch seeker and his wife Helen wrote about the Lost Dutchman Mine. Jones disappeared from the Superstitions in 1963. (Photograph by Jack Karie; courtesy SMHS.)

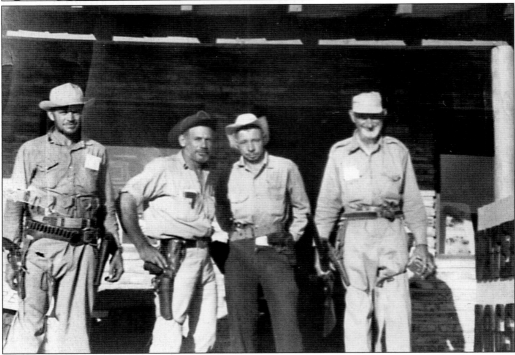

Ed Piper poses at far right with his well-armed army, including Bernie Gerhardt, John Bowers, and Baker Looney. Gerhardt remained with Piper until his death in 1962. Although people were not afraid of Piper, the same could not be said for his trigger-happy crew. On November 11, 1959, gunshots cracked the air and Robert St. Marie lay dead. Although the court ruled self-defense, Celeste Jones insisted Ed Piper assassinated her helper. Two weeks after St. Marie's death, Lavern Rowles died of gunshot wounds inflicted by Ralph Thomas after they visited at the Ed Piper Camp. A short while later, the body of Walter Mowry was found. Although his death was ruled a suicide, fingers pointed at the feuding parties. (Courtesy SMHS.)

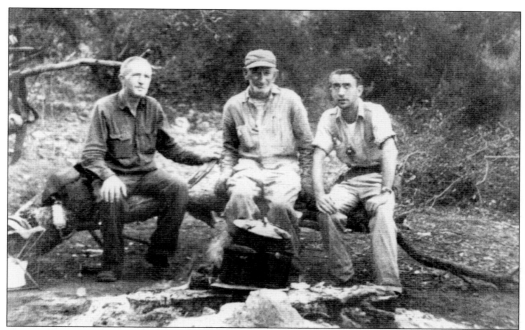

In 1953, Ed Mapes (left) and Robert Crandell (right) visit with Ed Piper at his camp. Piper, born in Kansas, arrived in the Superstitions after his wife's death in 1956 and set up a permanent camp near Weaver's Needle. Piper died of cancer on August 13, 1962, and was buried in a potter's field between Florence and Coolidge. His will requested he be buried in the shadow of Weaver's Needle, but that was prohibited by law. Some say that he is there anyway. (Courtesy SMHS.)

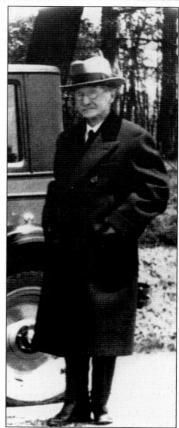

Adolph Ruth, a German immigrant, disappeared and died in the Superstition Mountains during his quest for Lost Dutchman Mine. After graduation from the Kansas City Veterinary College, he worked for the department of agriculture as a meat inspector. For years he collected lost treasure stories before he set out with his son Erwin to search for lost treasure in California's Borrego Desert. Ruth got lost and fell into a ravine, fracturing his hip, ending his quest. Ruth acquired the Peralta Mine map from his son, and on May 4, 1931, against his family's wishes, the frail 78-year-old Ruth bought a car and set out from Washington, D.C., with a young man who was going back to school in Washington state. At Tex Barkley's Quarter Circle U Ranch, he asked to be packed into the Superstitions. Barkley had business in Phoenix and he told Ruth to wait until he returned. Ruth would not wait. (Courtesy SMHS.)

Jeanne Ruth was the daughter-in-law of Adolph Ruth and wife of Adolph's son Erwin. (Courtesy SMHS.)

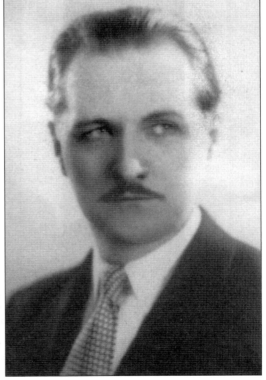

Erwin Ruth followed in his father's footsteps and became a veterinarian in 1907. Erwin also worked for the department of agriculture, but after several years his services proved unsatisfactory. He was fired on March 18, 1912. In 1913, while working at a car dealership in Parr, Texas, Erwin came to the attention of Mexican president Venustiano Carranza and went to work for the Mexican government on its tick-eradication problem. Erwin had become friends with a man named Gonzales, who was in prison awaiting execution. In return for escorting the Gonzales family safely across the border into the United States, Erwin received several old treasure maps, one of which was supposedly of the Lost Dutchman Mine.

In Tex Barkley's absence, Ruth (pictured at right) persuaded cowboys L. F. Purnell (left) and Jack Keenan (center) to pack him into the Superstitions. They are posing with Erwin Ruth. They guided him into Willow Springs in Boulder Canyon where there was permanent water. They used his car, which had been left at the ranch, and partied with their girlfriends in high style in Phoenix. Barkley was furious when he returned and set out immediately with a search party to find Ruth, but they would never find him alive. Barkley then notified the sheriffs of Pinal and Maricopa Counties, who mounted large posses, but by July 1931, the searches were called off. (Courtesy Superstition Mountain Historical Society, Oren Arnold Collection.)

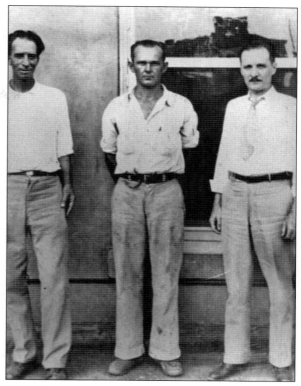

In December 1931, several months after Ruth's disappearance, the *Arizona Republic* and the Archaeological Commission of Phoenix sponsored an expedition to study the ancient ruins of the Superstition Mountains under the leadership of Odd S. Halseth. The dog that was brought along, Music, discovered at skull with a hole in each side. However, Halseth announced that skull was of a Native American and appeared to be very old. This was wishful thinking on his part because the skull was not even fully decomposed. Halseth sent the skull to Dr. Ales Hrdlicka, a forensic expert with the Smithsonian Institution in Washington, D.C., and he identified it as that of Adolph Ruth. (Photograph by D. E. Newcomer; courtesy SMHS.)

Maricopa County sheriff James R. McFadden took part in the search for Adolph Ruth and here he is holding Ruth's gun. McFadden, born in Hunt County, Texas, on August 28, 1889, arrived in Phoenix around 1911. He farmed and ranched while serving as sheriff. His most publicized cases were the Adolph Ruth disappearance and the Winnie Ruth Judd murderess case, which also occurred in 1931. Winnie Ruth Judd was found guilty of chopping up two women, packing them in a trunk, and shipping them off to Los Angeles. McFadden lost his bid for reelection in 1936 and went to work for the Arizona Department of Liquor License and Control. (Photograph by D. E. Newcomer; courtesy SMHS.)

The Barkley Cattle Company of Central Arizona was located in the heart of the Lost Dutchman Mine County. William Augustus "Tex" Barkley was born in Dyersburg, Tennessee, on August 11, 1879, and arrived in the Arizona Territory in 1885. He acquired the Bark-Criswell Ranch and eventually became the sole owner of the Quarter Circle U Ranch. Law enforcement agencies depended on Barkley to help them find lost persons in the mountains. He became famous for his part in the search for Adolph Ruth. (Photograph by D. E. Newcomer; courtesy SMHS.)

Pinal County sheriff Walter E. Laveen also relied on Tex Barkley for searches in the Superstition Mountains. Besides the Ruth disappearance, Laveen enlisted almost every able-bodied man to bring in Glenn Dague and Irene Schroeder, the pair who murdered a Pennsylvania peace officer and then traveled to Arizona. The murderous duo picked up another accomplice and held hostage Florence, Arizona, deputy Joe Chapman. Chapman had three fingers shot off his left hand, but escaped. Chandler marshal Lee Wright died from wounds incurred during the gunfight. Schroeder and Dague were returned to Pennsylvania where they died in the electric chair. (Photograph by D. E. Newcomer; courtesy SMHS.)

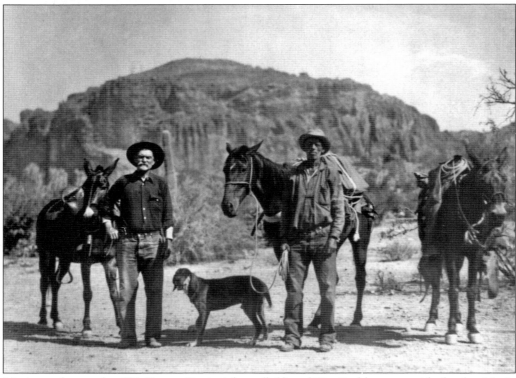

Maricopa deputy sheriff Jefferson Davis Adams (left) and Tex Barkley pose with the dog Music on the Ruth search. They found the rest of Ruth's body on January 8, 1932, about three-quarters of a mile from the skull. Music, who had actually sniffed out Ruth's skull, was in disgrace because the lion-hunting hound belonging to Richie Lewis had stolen and eaten all of the beef steaks planned for the evening meal the night before. Lewis later said if Music hadn't been such a good lion hound he would have shot him. That night the search party hung the skull in a tree to keep it from animals. Their campfire's dancing lights created an eerie effect, making even posse veterans uneasy. (Photograph by D. E. Newcomer; courtesy SMHS.)

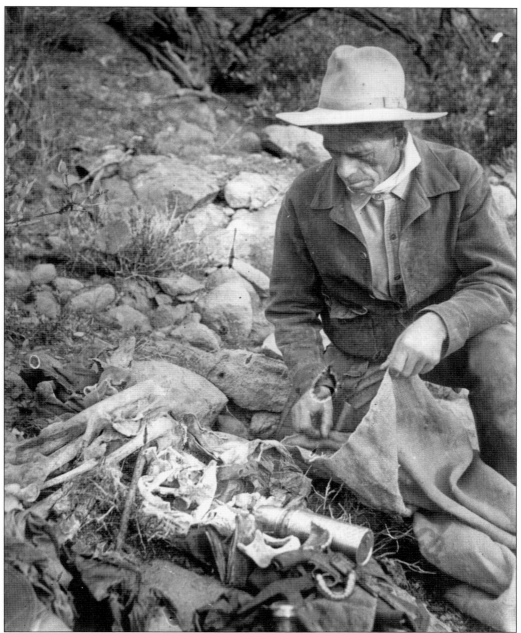

Tex Barkley packs up Adolph Ruth's personal effects. Ruth had scrawled the words *Veni, Vidi, Vici* (I came, I saw, I conquered) on a piece of paper. Ruth had also written, "It lies in an imaginary circle whose diameter is not more than five miles and whose center is marked by the Weaver's Needle, a prominent and fantastic pinnacle of volcanic tufa that rise a height of 2,500 feet among a confusion of lesser peaks." His remains also included a letter to his wife and children. (Photograph by D. E. Newcomer; courtesy SMHS.)

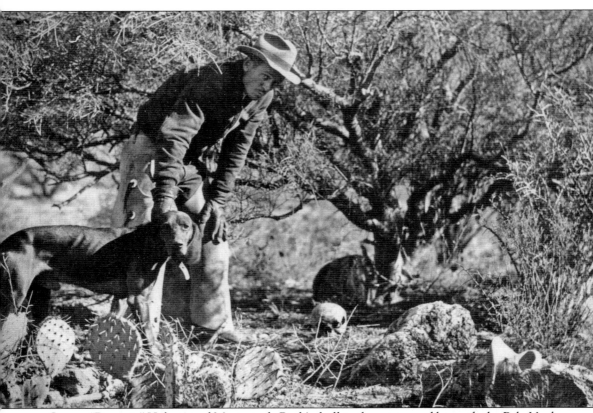

George "Brownie" Holmes and Music study Ruth's skull in the cactus and beneath the Palo Verde tree. Brownie left a manuscript that was given to him by his father, Dick Holmes. Dick supposedly knew Jacob Waltz and tried to steal his mine. He gave Brownie the manuscript that purported to be the true story of the Lost Dutchman Mine as told to his father, Richard, on his deathbed. Brownie, in turn, became a Dutch seeker. The manuscript is in the Arizona State Archives. (Photograph by D. E. Newcomer; courtesy SMHS.)

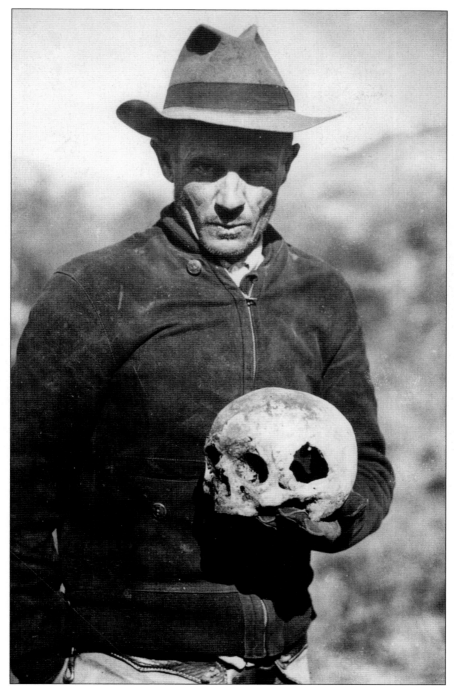

George "Brownie" Holmes poses with Adolph Ruth's skull. Most would agree the hole came from a bullet, but others propose that a coyote made the hole. Brownie Holmes was born in Phoenix, Arizona Territory on April 11, 1892 one year after the death of Jacob Waltz. He died on October 25, 1981, at age 88. He is buried in his beloved Superstition Mountains. (Photograph by D. E. Newcomer; courtesy SMHS.)

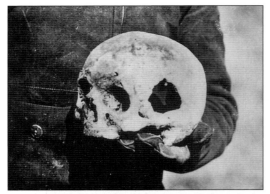

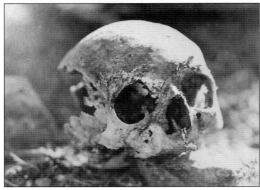

These views show both sides of Adolph Ruth's skull. It was presumed that he was murdered for Lost Dutchman Mine information, but curiously, Ruth's maps and directions to the mine were left behind. The steel plate that he had received during an operation after his fall in the Borrego Desert positively identified Ruth's skeleton. Forensic expert Dr. Ales Hrdlicka wrote that his examination determined that "the man was shot to death by a high-powered gun and that the bullet passed downwardly from the left." (Photograph by D. E. Newcomer; courtesy SMHS.)

In 1931, Brownie Holmes (left) and Richie Lewis participated in a search for Adolph Ruth. The dog Music belonged to Lewis, a champion bronco rider rodeo star who operated the Tempe Riding Academy and was a master of horses as well as tracking hounds. Lewis brought Music along on the archaeological expedition in hopes that he might smell a mountain lion. Music liked stealing beef steaks from the cook tent much better than chasing mountain lions. (Photograph by D. E. Newcomer; courtesy SMHS.)

This well-provisioned party was just one of several search groups who combed the Superstition Mountains in search of Adolph Ruth. On the chance that Ruth was possibly lying injured and unconscious, they searched for him up and down all the canyons shouting his name repeatedly and firing their revolvers at intervals. The search parties in the mountains were all anxious to find the Dutch seeker. Mrs. Ruth offered a reward, and her son, Dr. Erwin Ruth, spent time directing the search. When the fate of Ruth became known, the discovery was a gruesome one. Erwin Ruth sent the skull to Washington, D.C., where upon examination by the family dentist it was identified as the skull of Adolph Ruth. (Photograph by D. E. Newcomer; courtesy SMHS.)

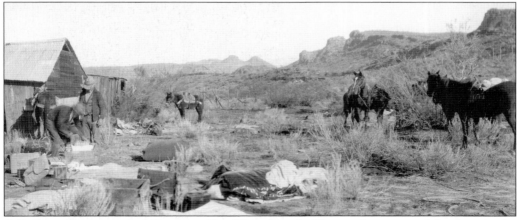

A Ruth search party is breaking up at First Water Ranch. The ranch was one of the three in the Superstition Mountains owned by the Barkley Cattle Company. (Photograph by D. E. Newcomer; courtesy SMHS.)

Brownie Holmes packs a mule for the Adolph Ruth search. (Photograph by D. E. Newcomer; courtesy SMHS.)

Brownie Holmes tightens the cinch. (Photograph by D. E. Newcomer; courtesy SMHS.)

The searchers make certain that the mule is properly balanced. (Photograph by D. E. Newcomer; courtesy SMHS.)

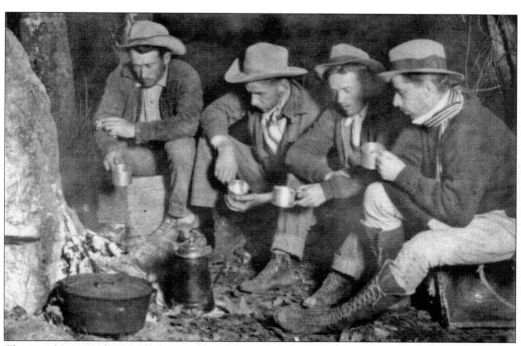

The search party takes a well-deserved break from the expedition to study ruins in the Superstitions. Pictured, from left to right, are Richie Lewis, *Arizona Republic* photographer D. E. Newcomb, expedition guide Brownie Holmes, and *Arizona Republic* staff writer Harvey Mott. The discovery of Adolph Ruth's skull and corpse brought to closure what happened to Ruth, but it did nothing to dispel speculations about who did it and why. (Photograph by D. E. Newcomer; courtesy SMHS.)

Walter Gassler became interested in the Lost Dutchman Mine as a young man, and after raising a family in California he returned to the Superstitions. Gassler set out on a search, but was 82 years old. His wife drove him to First Water Trail Head, and on May 4, 1984, two men spotted Gassler sitting on a rock, propped up dead. They notified the sheriff. Gassler's death was ruled to have been from natural causes. Before long, a man showed up in Apache Junction claiming to be Gassler's son Roland. He insisted that his father had found the Lost Dutchman Mine and he asked Tom Kollenborn for the manuscript and maps that Gassler lent him. Kollenborn readily gave him these materials. Several weeks later, while Kollenborn was giving a presentation on the Superstition Mountains, a man came up and introduced himself as Roland Gassler. He was not same man who had earlier claimed to be his son, and this second man turned out to be the real Roland Gassler. Just who was the first Roland Gassler and where did his gold come from remains a mystery. The fake Roland Gassler was never seen again. (Courtesy SMHS.)

On November 10, 1949, a car screeched to a stop and a door slammed shut. James Kidd, a prospector in his seventies, left and never returned to his $4-a-week room in Phoenix, Arizona. In 1933, he had registered two mining claims, Scorpion 1 and Scorpion 2, at the Gila County Recorder's Office. Some think these claims are in the Superstition Mountains. On January 11, 1964, a state auditor discovered Kidd's will. He left his estate to anyone who could provide proof of existence of the soul leaving the body at the time of death. The will resulted in Arizona's great soul trial. Ultimately, the money went to the American Society for Psychical Research. The mystery remains unsolved. (Courtesy author.)

Four

THE TREK OF THE DONS

No organization has done more to preserve the lore and history of the Lost Dutchman Mine than the Dons. The club originally began in the early 1930s and was an adjunct of the Phoenix Young Men's Christian Association (YMCA). The young businessmen and professional men of Phoenix felt there was a need for a luncheon club where they could gather and discuss the civic, social, and economic interests of the community. Membership was limited to two men from each business or profession. Members had to exhibit "personal efficiency, good character and substantial patriotism." A constitution was drafted and by-laws were adopted to provide a basis for operation.

In October of 1931, the Dons decided to split off from the YMCA and the organization changed its name to the Dons Club to reflect members' interest in the lore and history of the Southwest. Members' wives, called Doñas, became an important auxiliary part of the group. In 1979, the club's name was changed to the Dons of Arizona to reflect a broader scope of operations and functions. Today, the Dons remain an unaffiliated, non-profit service group. For more than 65 years, the Dons' goal has been the study, preservation, and public presentation of the history, legends and lore—plus the cultures and grandiose scenery—of Arizona and the Southwest. One of the Dons' activities is hosting fourth-grade students at its Discovery Camps.

Arthur Weber, the physical education director of the Phoenix YMCA, was a founder of the Dons. He explored the Superstitions for many years and collected an impressive array of rocks and gemstones from the area. In the beginning, Weber gathered together a group of young men from his gym classes and other branches of the YMCA as a nuclear basis for the club that would become the Dons. (Courtesy SMHS.)

Ozzie Foster, an early president of the Dons, wears the club's costume, which was modeled on those worn by the Spanish dons who brought their culture to Arizona over 400 years ago. (Courtesy SMHS.)

Gregory Davis, who serves as the historian of the Dons, has been collecting documentation and photographs of the Superstition Mountains for more than 40 years. (Photograph by Greg Davis; courtesy SMHS.)

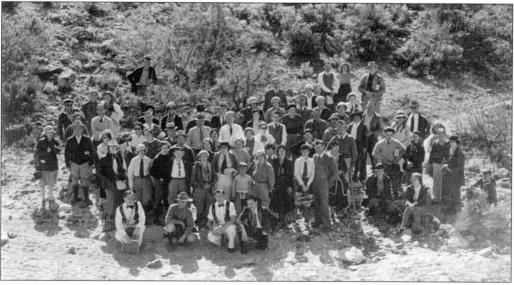

The Dons and the Doñas hold a meeting in the Superstition Mountains in 1934. One of the most popular activities of the Dons was the annual Sunday desert trek into the Superstition Mountains to find the Lost Dutchman Mine. One of the trekkers was young western writer Oren Arnold. Besides writing about the Lost Dutchman Mine, Arnold wrote a series of radio programs entitled, *In the Days of the Dons.* (Courtesy SMHS.)

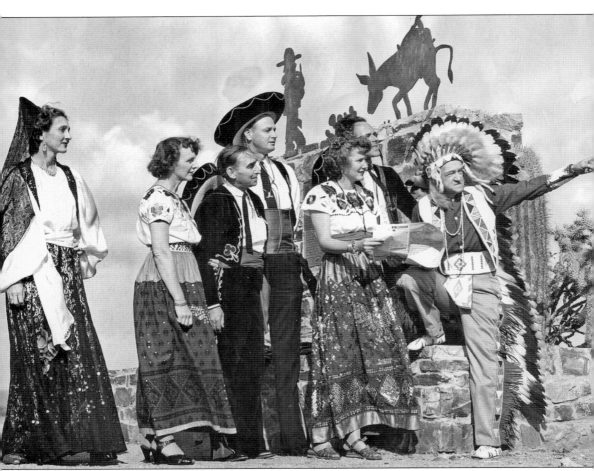

Fred Wilson, in a Native American costume, points to the Superstition Mountains and recounts the legend of the Lost Dutchman Mine to the Dons, who are planning a trek into the mountains. The group is standing in front of a statue of Jacob Waltz, the man who took the secret of his rich mine to the grave. (Courtesy SMHS.)

Karen Mackey, Mary Rogers, Esther Blaine, and Juanita Foster pose in the elegant costumes of the Doñas. (Courtesy SMHS.)

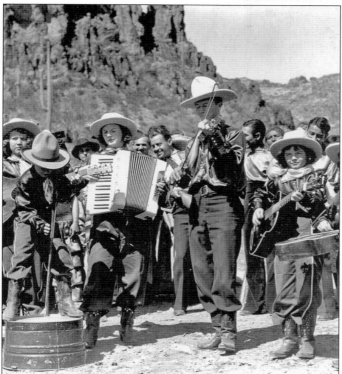

When the Dons decided to devote a day and evening to the search for the Lost Dutchman Mine, they added other Old West entertainments, including Mexican singers and dancers, cowboy musicians, and Native American arts and crafts. Of course food was also an important part of the ceremony. (Courtesy SMHS.)

Water, the all-important commodity in the desert, is carried in by barrels on a mule. The Dons and their wives would meet the previous evenings to pack lunches. On Sunday morning, they would meet at the Fox Theater in Phoenix to begin the trek. A chartered bus carried those who did not have transportation. The cavalcade was escorted to the mountain by a detail from the Arizona Highways Department. The group would reach First Water Ranch about midmorning and the trekkers would be on their way. (Courtesy SMHS.)

One of the Dons sketches out a Lost Dutchman map in the sand while others listen attentively. (Courtesy SMHS.)

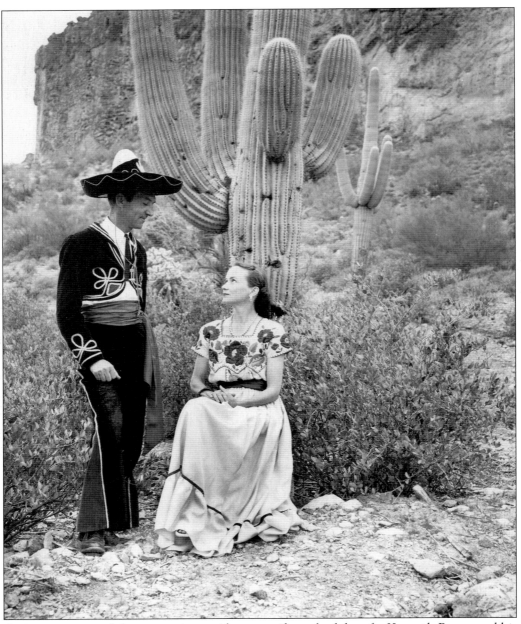

A giant saguaro and the mountain provide a magnificent backdrop for Kenneth Brown and his lady Helen in 1948. (Courtesy SMHS.)

The treks grew in popularity and in 1936 there were two. Those who journeyed included not only the Dons, but also others from the area that wanted to join them for this very special event. Still, the 50 members of the Dons were responsible for the logistics, which were becoming more formidable. (Courtesy SMHS.)

For 40 years, Mr. and Mrs. Miller bought the first ticket for the Trek of the Dons into the Superstitions. In this photograph, they are purchasing their ticket from Ace and Ron Briest. (Courtesy SMHS.)

This is one of the actors who portrayed Jacob Waltz, known also as Old Snow Beard. (Courtesy SMHS.)

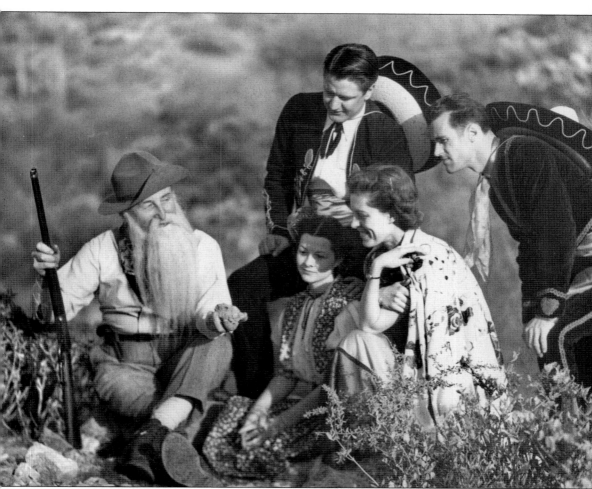

From the smiles on their faces, old Jacob Waltz must be telling the Dons and Doñas where they can find his gold. (Courtesy SMHS.)

Native American arts and crafts were popular attractions at the Dons' events. Their first program almost sold out. The second Native American event was held at the Westward Ho, and the Apache program with the Crown dancers almost brought down the house. When a very heavy Apache began dancing, the ceiling fixtures swung. (Courtesy SMHS.)

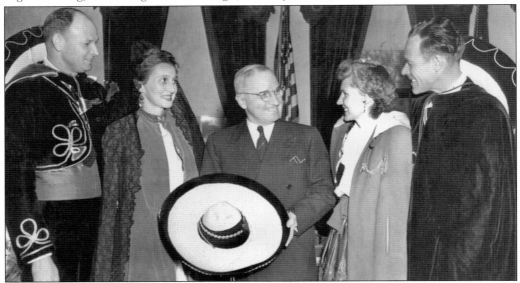

In 1946, after World War II, it was decided to revive the Trek of the Dons. For publicity, a group in full costume traveled to Washington, D.C., making 30 stops en route. At the capital, the group visited with President Harry S Truman and made him an honorary Don. Many prominent people have been members in the Dons, including E. Oren Arnold, Trek originator; Bob Corbin, former attorney general of Arizona; Don Dedera, an Arizona author; Harry H. Gilleland, historian on dams and water usage concepts; Barry Goldwater, former U.S. senator; Hal Gras, wildlife conservationist; Carl Hayden, former U.S. senator; Earnest MacFarland, former U.S. senator and Arizona governor; Reg Manning, Pulitzer Prize–winning cartoonist; Eugene Pulliam, publisher; Dr. Clarence G. Salsbury, doctor to the Navajos; Dr. Herbert L. Stahnke, world authority on poisonous animals; and Harry S. Truman, former president of the United States. (Courtesy SMHS.)

Five

APACHE JUNCTION AND OTHER SUPERSTITION MOUNTAIN COMMUNITIES

Apache Junction lies at the junction of the Apache Trail with the main highway from Phoenix to Superior. It is located near the foot of the scenic Superstition Mountains at the junction of U.S. Highways 60 and 89 and State Highway 88. Apache Junction's first citizen and a salesman of ready-to-wear clothes, George Cleveland Curtis filed a homestead claim on 160 acres on what would become Apache Junction. Today, the town attracts almost 40,000 winter visitors because of its proximity to many recreational and historic areas. The Apache Trail, which winds north from the town, is a scenic drive to recreation areas in Salt River Canyon, but a bigger attraction are the Superstition Mountains, reputed to be the site of the Lost Dutchman Mine. Many explorers have claimed they found the mine, but none have brought out significant gold. That is not to say that there has not been substantial mining activity in the area. Curtis might not recognize the 30,000 visitors, but he would certainly know the Superstition Mountains with its miners, ranchers, and mountain men all searching for the elusive Lost Dutchman Mine.

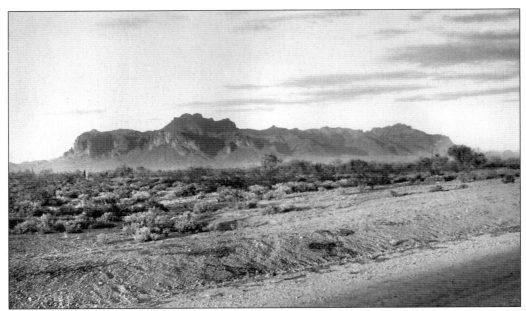

Millions of years ago, during the tertiary geologic era, the earth's crust heaved and shuddered as heat created fissures and formed the large volcanic plateau known as the Superstition Mountains. Weaver's Needle and Superstition Mountain, born of fire, stand in mute testimony to a violent geologic past. (Courtesy SMHS.)

Royal Luebkin served as the official Dutchman for the Apache Junction Chamber of Commerce. (Courtesy SMHS.)

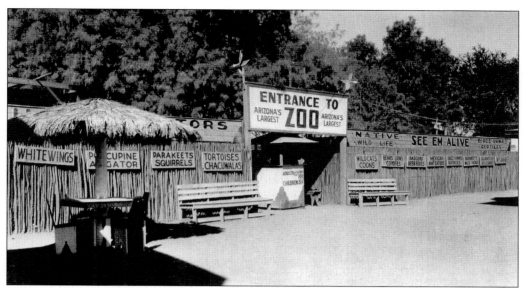

Gorge C. Curtis started the first zoo in Arizona with a monkey named Jimmie. Chained to a tree in front of the Apache Junction Inn, Jimmie attracted visitors, so before long Curtis added an a lion, a deer, an alligator, tortoises, and a variety of birds to his menagerie. (Courtesy SMHS.)

Curtis attempts to add statuary to his zoo left visitors both perplexed and entertained. Tourism went into a decline in the 1920s, but the Bureau of Reclamation built Horse Mesa Dam and Mormon Flat Dam, thus providing Curtis with business from construction and people working for the Civilian Conservation Corps during the Depression. (Courtesy SMHS.)

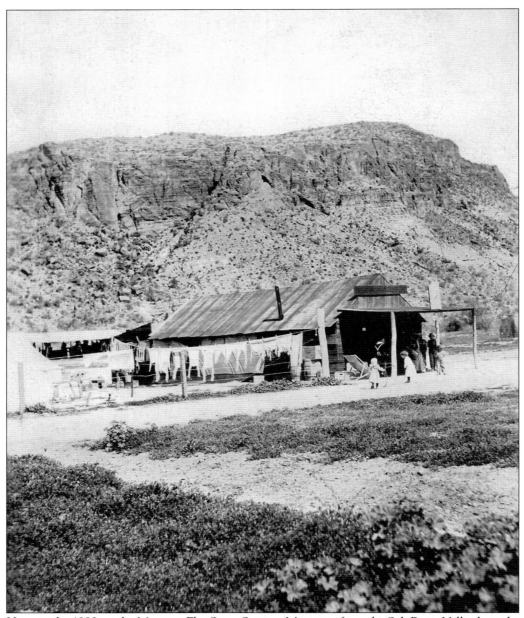

Here, in the 1880s at the Mormon Flat Stage Station, Mormons from the Salt River Valley brought stock to graze on the flat at the junction of the Salt River and La Barge Creek. Later, when the Apache Trail stage drivers drove their passengers past this spot, the passengers endured untrue tales of Apache massacres. (Courtesy Arizona State Library, Archives and Public Records.)

Ned Cross started the Oasis Bar about seven miles west of the Apache Zoo. By 1924, Cross planted citrus trees, palm trees, and drilled a well. Cross sold cold drinks, melons, and sandwiches, and when prohibition was repealed he obtained the second liquor license in Arizona and opened the Oasis Bar. He covered the roof with palm fronds. The original building burned down in 1944 and the rebuilt bar opened in the 1970s. Ned died on January 31, 1981, and the second Oasis Bar burned down on June 13, 1986. (Courtesy SMHS.)

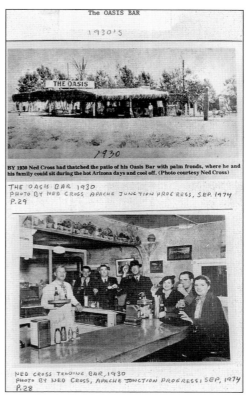

The OASIS BAR

1930'S

THE OASIS

1930

BY 1930 Ned Cross had thatched the patio of his Oasis Bar with palm fronds, where he and his family could sit during the hot Arizona days and cool off. (Photo courtesy Ned Cross)

THE OASIS BAR 1930
PHOTO BY NED CROSS APACHE JUNCTION PROGRESS, SEP. 1974
P. 29

NED CROSS TENDING BAR, 1930
PHOTO BY NED CROSS, APACHE JUNCTION PROGRESS, SEP. 1974
P. 28

Ben Curtis was part of the first family of Apache Junction. (Courtesy Curtis family and SMHS.)

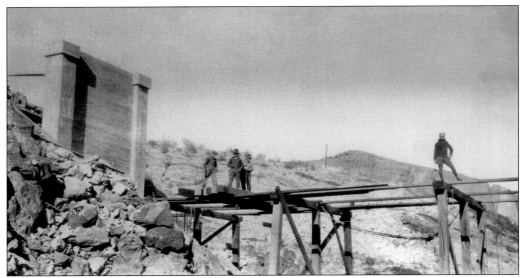

An intrepid worker stands precariously on the site of Mormon Flat Dam. The Salt River Water User's Association began construction on Mormon Flat Dam on July 1, 1923, and workmen poured the first concrete in March 1924. When Mormon Flat Dam was completed on January 12, 1925, it stood 225 feet above bedrock. It was 25 feet thick at the base and 12 feet thick at the top. The dam was 320 feet long and 160 feet above the river. The dam would impound about 98,000 acre feet of water and form a storage lake about 14 miles long. Selling bonds voted on by a majority of the association shareholders raised the $1.8 million cost of dam. On major construction jobs such as that of Mormon Flat Dam, men often died in accidents. On July 31, 1924, George Furr and Harry Anderson, both about 30 years old, fell more than 100 feet from a concrete chute. Furr died instantly and Anderson died two days later at the Southside Hospital in Mesa. (Courtesy Arizona State Library, Archives and Public Records.)

George L. Curtis was one of the Curtis family pioneers in Apache Junction. (Courtesy Curtis family and SMHS.)

Melissa Curtis was the matriarch of the Curtis family pioneers. (Courtesy Curtis family and SMHS.)

Dick and Ida Holmes were the parents of longtime Dutch seeker George "Brownie" Holmes. Dick was born close to Fort Whipple, near Prescott, in 1865. He worked for the Indian scout Al Sieber and as a cowboy in the Bloody Basin area. He married Ida Davis, and their son Brownie was born in Phoenix in 1892. Dick claimed that he and Albert Shaffer rescued Jacob Waltz when he was clinging to a tree after flood inundated his farm along with much of central Arizona in 1891. (Courtesy SMHS.)

Charles Radria and Henry Zenner pose with a friend. (Courtesy Curtis family and SMHS.)

This is one of the many small mining operations in the Superstition Mountains. (Courtesy SMHS.)

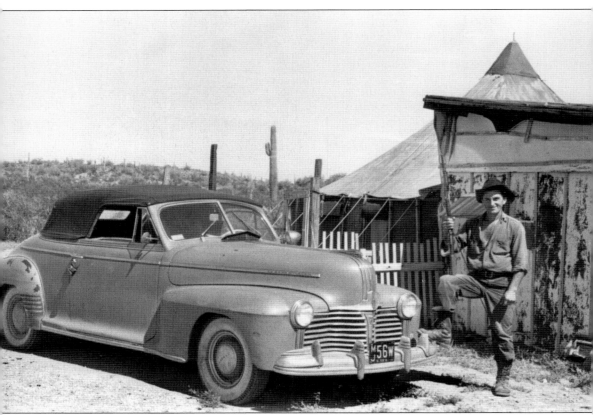

Cecil Broderick was an explorer and resident of the ghost town of Morristown. It was first called Vulture Siding because of its proximity to the Vulture Mine. When the mine played out, the name was first became Hot Springs Junction before later changing to Morristown in honor of its first resident, George Morris, who discovered the Mack Morris Mine. (Courtesy SMHS.)

In 1904, Charles F. Weekes II purchased land on the Apache Trail and opened a stage stop station to service freighters. In 1924, Charles Weekes III purchased the operation and went into ranching with an operation that had 600 head of cattle in its heyday. They were generous, but they requested travelers pay 5¢ for the water they took. (Courtesy SMHS.)

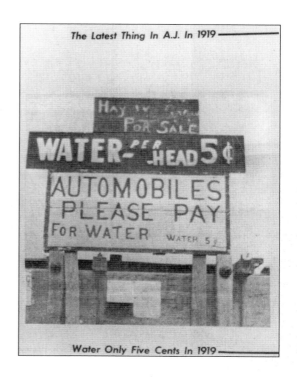

The Blue Bird Mine, in the Superstition Mining District, encouraged tourism and boasted a gift shop. In the 1890s, it produced its first ore when J. R. Morse sank a shaft 60 feet down. A quartz vein, three feet wide in some places, carried free gold strikes. (Courtesy author.)

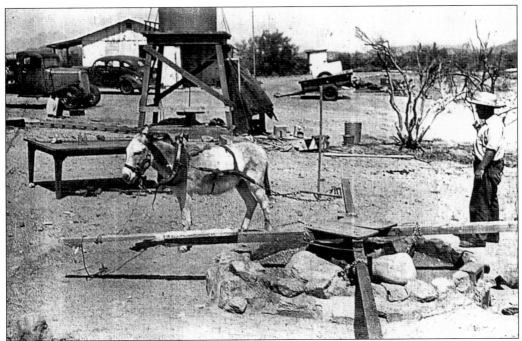

In the 1950s, George "Red" Monagan constructed an *arrastre*, an old Spanish grinding mill, for crushing and grinding the gold ore. Monagan also put in 140 feet of tunnel. Glen Hamaker later continued the tunnel another 85 feet through a hill. (Photograph by Ruiz; courtesy SMHS.)

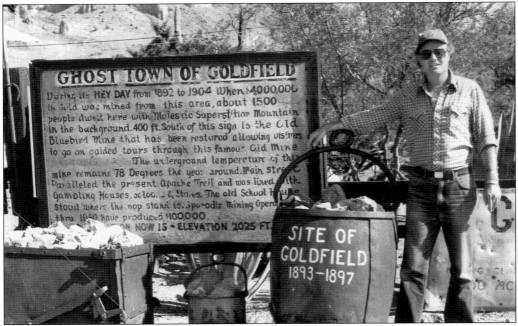

John D. Wilburn staked the Nugget Hill on December 8, 1960, in Goldfield. He found a little gold and went on to develop the Black Queen Mine, which he sold to the Clark and Oliver Mining Company. Wilburn eventually published the book *The Riddle of The Lost Dutchman*. (Courtesy SMHS.)

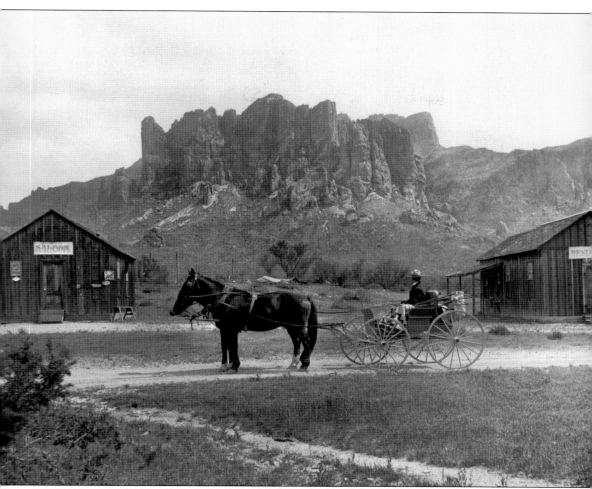

Goldfield is now a ghost in Arizona history, but once it flourished with prospects of work and gold. The town site was laid out in 1893 by Mesa citizens who wanted to purchase and sell lots. A traveler may have been torn between Goldfield's restaurant and saloon, but there is no doubt that he or she was in the shadow of the Superstition Mountain. (Courtesy SMHS.)

The Goldfield office may not look like much, but its owners were out to find gold and ready to forego many of the amenities of life. Mine superintendent Frank Massey often slept in this building. On November 24, 1892, four prospectors, C. R. Hakes, Orland Merrill, Orrin Merrill, and J. R. Morse, filed on the Black Queen Mine, on November 27, 1892, 13 months after the death of Jacob Waltz. Their discovery led to the Mammoth Mine and Mormon Stope (a stope is a mine excavation for ore that is accessible by shafts) being rich in gold. Within three years, almost a $1 million in gold was extracted from the Mormon Stope. (Courtesy SMHS.)

Andy Syndbact reflects a more modern time with his hard hat. Here he stops work on a shaft near Goldfield just long enough to pose for a picture. (Courtesy SMHS.)

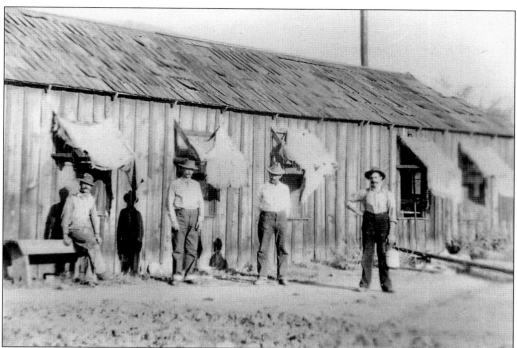

Men found food and lodging at the Goldfield boarding house. (Courtesy SMHS.)

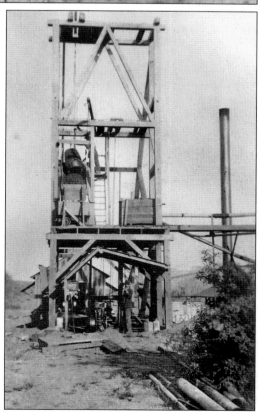

This view looks west toward the head frame of the south Goldfield shaft during the time when A. C. Massey was superintendent and George U. Young was the owner. Young, an ex-mayor of Phoenix, acquired the Goldfield property in 1910 and incorporated it under the Young Mines Company Limited. Young spent 15 years looking, with some success, for gold, and he sank a shaft down 900 feet. He became the postmaster and changed the name to Youngsberg. In the 1980s, the name was changed back to Goldfield. The head frame was still standing in 1956. (Courtesy Massey family and SMHS.)

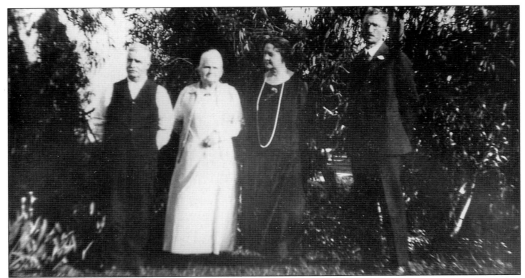

In 1922, the Goldfield Mine Superintendent Frank Massey and his wife, Lillie, posed for this picture with their son A. C. Massey and his wife. A. C. also served as superintendent of the mine. (Courtesy SMHS.)

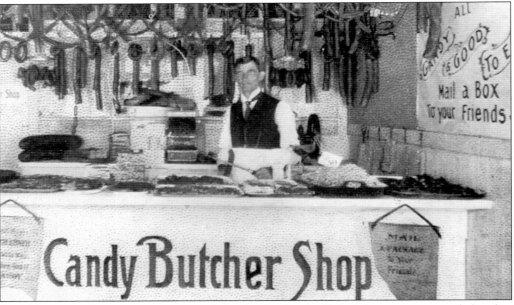

Emil Thomas, a German immigrant and the first husband of Julia Thomas, ran a candy butcher shop—an unusual business, even for Arizona. Unfortunately, there is no known photograph of Julia Thomas, who was living with Jacob Waltz when he died. Julia was an African American Cajun woman from Louisiana. When Emil deserted her for a white woman and took all their money, she went to Jacob Waltz for help. He supposedly left her a map and the gold under his bed. After his death, she mounted several excursions into the Superstitions to try and find the gold. She married Albert Schaffer and spent her later years preaching a special religion known as the New Israel. When Julia died in 1919, her estate was worth around $7,000, a significant sum in those days. (Courtesy SMHS.)

On July 17, 1897, James Stevens had survived almost two weeks without food or water after being trapped when the entire Mormon Stope at the Mammoth Mine collapsed. Workers labored day and night to free the entombed miner, but after the several days hope for his survival faded. Upon his miraculous rescue, the 42-year-old native of Devonshire, England, said, "I never felt weak, even when rescued, and could easily have climbed the ladder of shaft if they would have let me." His words give a whole new meaning to hardy pioneer. (Courtesy SMHS.)

In the annals of western outlawry, William Larkin Stiles deserves more than mere mention. Stiles was born in Casa Grande, Arizona, and ranched and prospected in the Superstition area before taking up train robbing in southern Arizona. He became friends with Burt Alvord, and the two men served as occasional deputy sheriffs. In 1899, their robbery of the Southern Pacific turned out to be a fiasco. When apprehended, Stiles and Alvord blamed each other. Stiles's wife testified against her husband during the trial. Alvord actually freed Stiles from jail—by tying up the jailer, taking the keys, and opening the cell—and they disappeared. It is said the that a few years later, while serving as a Nevada County sheriff under the name of William Larkin, Stiles was shot when he tried to deliver a court summons. (Courtesy SMHS.)

Albert Erland Morrow once said, "If I die here, it is the will of God and the Old Dutchman has won another round." Morrow arrived in Needle Canyon in 1949 and searched for gold until 1957 when he went to Kansas. He returned in 1959 when he set up this camp in Needle Canyon. Morrow became known as the "Samaritan of Superstition Mountain." He never turned anyone away who was hungry or needed help. He searched for answers to universal questions and hand-copied the entire Bible several times during his time in the Superstitions. On September 9, 1970, Morrow's crushed body was discovered beneath a large boulder after perishing in a cave-in. Amos Hawkins, Bud Lane, Calvin Hill, and member of the Pinal County Sheriff's posse removed his body. (Courtesy SMHS.)

For several years, a man remembered only as Shupp hung around Apache Junction and claimed that he knew Jacob Waltz. At the time of this 1971 photograph, he was 89 years old. (Courtesy SMHS.)

Francisco "Pancho" Monroy claimed that Jacob Waltz would pass his ranch whenever he went out prospecting. Here Edwin B. Hill stands by Mr. Monroy. (Courtesy SMHS.)

Benjamin Regan, founder of the rich Silver King Mine, poses here with his wife and dog. Apaches attacked Charles Mason, Benjamin Regan, William Long, Isaac Copeland, and a fourth man while returning from Globe. The unidentified man was murdered, but the other four men escaped and went on to become very wealthy. That night, they began looking for the Lost Sullivan Ledge. Regan found it, and they staked their claims the next day. The ore was very rich with silver. (Courtesy SMHS.)

Ritchie Lewis was a world-champion bronco rider and mountain-lion hunter from Tempe, Arizona. Lewis was often called upon to help in searches for the Dutch seekers. And it was his dog Music who discovered the skull of Adolph Ruth. (Courtesy SMHS.)

Lizzie and Ray Howland set up a permanent camp in the Superstitions. Lizzie claimed to be a niece of Jacob Waltz. Sims Ely and James Bark gave them a map with the following instructions: "Trail leads up the first long draw leading into the Superstition Mountains, east from the west end on the south side. Then on across the mesa and down past a *picacho* (peak) on the left hand side and into a big canyon that leads to a Salt River, then up the first right hand canyon and out onto a flat to a big pit. Note: Do not mistake the Canyon for the trail." They never found the gold either. (Courtesy SMHS.)

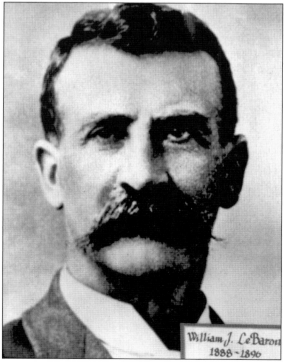

William J. LeBaron
1888~1896

William Le Baron was a member of the First Mesa Company, which included 85 members who left Utah and Idaho in September 1877 to look for new farmland. The company leaders, some of whom were polygamous, included Crismon, Pomeroy, Sirrine, and Robson. They crossed the Colorado River at Lee's Ferry, and the newly arrived Mormons marked off land and immediately began work clearing the original Hohokam canals. Water entered the canals in April 1878.

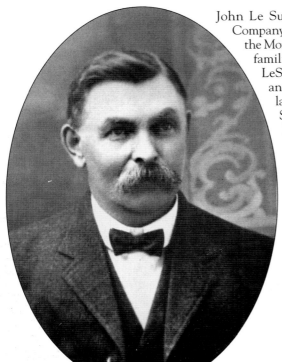

John Le Sueur was a member of the Second Mesa Company, which came from Idaho in 1879. as part of the Mormon migration to find better farmland. These families included the Phelps, Hibbert, Dana, and LeSueur families. In 1880, the Rogers, Standage, and Pew families arrived, but because the best land had been taken these pioneers established Stringtown, along what is now Alma School Road. The Standage Farm became the University of Arizona Experimental Farm. In the late 1990s, a Wal-Mart Shopping Center and the East Valley Institute of Technology were built on the site. (Courtesy SMHS.)

W. Irven Lively worked in real estate and ran for Phoenix city commissioner in 1933. He offered a platform that included cheaper utilities and a lower power rate for a street railway system. He cited his qualifications as being a property owner and having paid more in taxes than for his groceries. Moreover, he did not countenance the confiscation of property, even under due process of law. (Courtesy SMHS.)

Six

THE APACHE TRAIL
AND ROOSEVELT DAM

Desert communities, such as Apache Junction and the nearby burgeoning metropolis of Phoenix, needed the water that could be supplied by controlling the flow of the Salt River. The Apache Trail or State Highway 88 had to be built to get to the area where the dam would be constructed. Teddy Roosevelt described the Apache Trail as "one of the most spectacular, best-worth-seeing sights in the world."

Roosevelt Dam, constructed between 1905 and 1911, was built to control the flow of the Salt River and to harness the water for irrigation. Once the world's tallest masonry dam, it is named after Pres. Theodore Roosevelt, who was instrumental in approval of the Federal Reclamation Act of 1902. He dedicated the dam in March 1911. This unique structure uses huge, irregular blocks that are now covered by new concrete. In 1996, a $430 million modification project was completed that raised the height of the dam to 357 feet and expanded the lake's storage capacity by 20 percent—enough for 1 million more people. Renovations at Roosevelt Dam used 444,000 cubic yards of concrete, enough to pave a two-lane road from Phoenix to Tucson.

An entourage of Gov. George Hunt (at center, in a short gray coat) sets out to explore the Apache Trail. George Wylie Paul Hunt's political opponents poked fun at him because of his limited education and unpolished manners, but the people loved him and elected him to the territorial legislature. In 1911, he was elected as Arizona's first state governor, and he won reelection seven times, earning him the title of George the 5th, George the 6th, etc. Hunt, who was born in Missouri on November 1, 1859, had less than eight years of schooling. He arrived penniless in Globe, Arizona, in 1818, where he waited tables, worked in the mines, and clerked in the company store in Globe. By 1900, he was president of the company and Globe's mayor. As Arizona's first governor, he refused a carriage for his inauguration ride and walked a mile to the capitol on February 14, 1912. (Courtesy Arizona State Library, Archives and Public Records.)

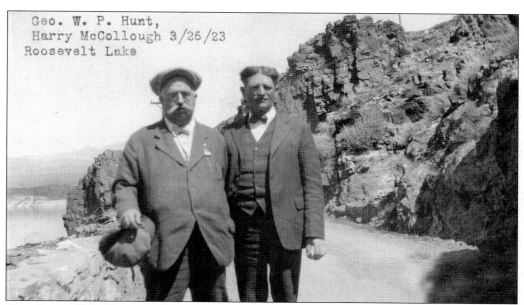

Geo. W. P. Hunt,
Harry McCollough 3/26/23
Roosevelt Lake

Gov. George W. P. Hunt and Harry McCollough visited Roosevelt Lake on March 26, 1923. Hunt issued a proclamation making April 15, 1915, a special holiday in Gila and Maricopa Counties to celebrate the filling of Roosevelt Lake. Hunt strongly supported legislation to aid the mining industry and he backed farming by urging the construction of dams and irrigation projects. (Courtesy Arizona State Library, Archives and Public Records.)

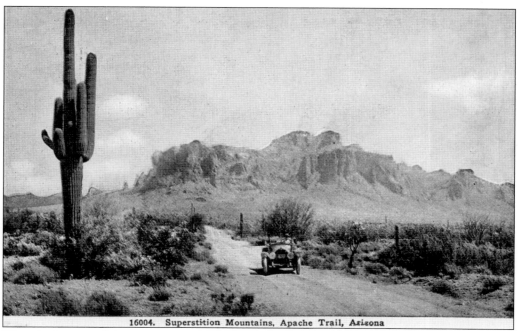

16004. Superstition Mountains, Apache Trail, Arizona

The tin lizzie will be coming around the Superstition Mountain when she comes . . . (Courtesy author.)

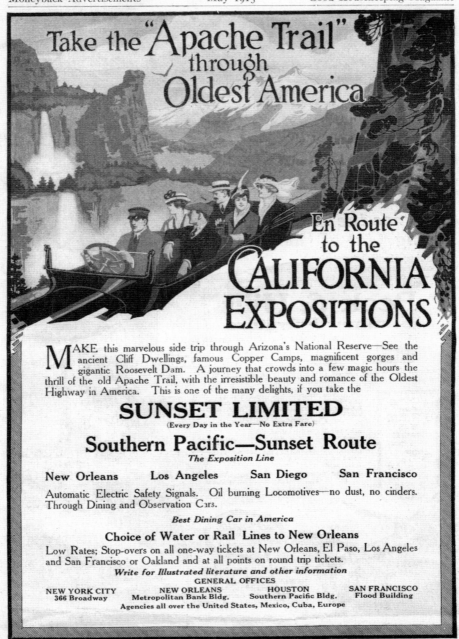

Take the "Apache Trail" through Oldest America

En Route to the CALIFORNIA EXPOSITIONS

MAKE this marvelous side trip through Arizona's National Reserve—See the ancient Cliff Dwellings, famous Copper Camps, magnificent gorges and gigantic Roosevelt Dam. A journey that crowds into a few magic hours the thrill of the old Apache Trail, with the irresistible beauty and romance of the Oldest Highway in America. This is one of the many delights, if you take the

SUNSET LIMITED
(Every Day in the Year—No Extra Fare)

Southern Pacific—Sunset Route
The Exposition Line

New Orleans Los Angeles San Diego San Francisco

Automatic Electric Safety Signals. Oil burning Locomotives—no dust, no cinders. Through Dining and Observation Cars.

Best Dining Car in America

Choice of Water or Rail Lines to New Orleans

Low Rates; Stop-overs on all one-way tickets at New Orleans, El Paso, Los Angeles and San Francisco or Oakland and at all points on round trip tickets.

Write for Illustrated literature and other information

GENERAL OFFICES

NEW YORK CITY	NEW ORLEANS	HOUSTON	SAN FRANCISCO
366 Broadway	Metropolitan Bank Bldg.	Southern Pacific Bldg.	Flood Building

Agencies all over the United States, Mexico, Cuba, Europe

If you have any cause at all for dissatisfaction, use COMPLAINT BLANK on page 14

32

An advertisement in the May 1913 issue of *Good Housekeeping Magazine* extolled the beauty of touring the Apache Trail with stops at ancient cliff dwellings and the Roosevelt Dam. The trip could be made either by automobile or on the Sunset Limited of the Southern Pacific. The train boasted oil-burning locomotives with no dust or cinders.

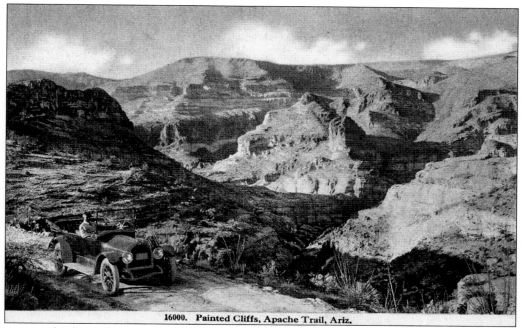

16000. Painted Cliffs, Apache Trail, Ariz.

. . . and when she arrives, she will enter the Painted Cliffs of the Apache Trail. (Courtesy author.)

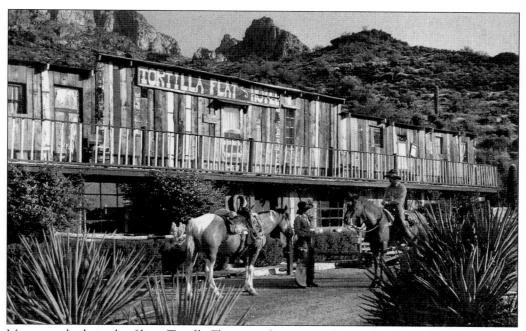

Many are the legends of how Tortilla Flat earned its name. One is that a group of lost, hungry travelers were making their way through the area when one of them looked at a rock formation and said, "Hey that flat bluff looks like a stack of tortillas. Sure wish I could get my hands on them. I'm hungry." (Courtesy author.)

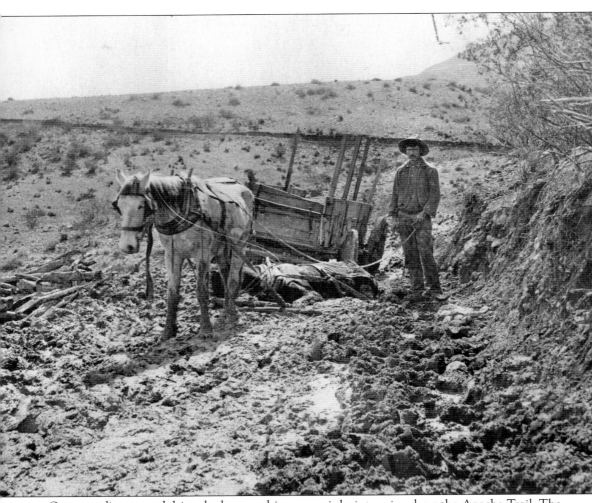

One very discouraged driver looks on as his wagon sinks into mire along the Apache Trail. The Apache Trial would become the "haul road" between Mesa and Roosevelt Dam. By September 1905, teamsters had hauled 1.5 million pounds of freight per month to the Roosevelt Dam area. (Courtesy Salt River Project.)

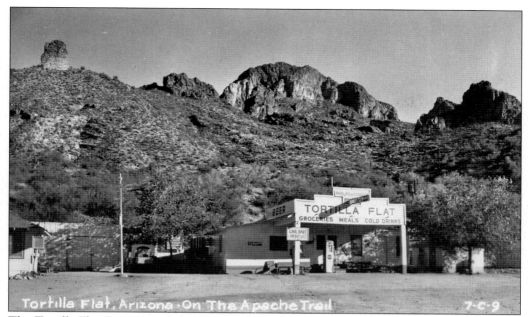

The Tortilla Flat Store provided visitors with food, cold drinks, and gasoline. The story has is that a gang of hellions came into town intent on robbing the business, but when they were so overwhelmed by the hospitality of the residents, they stayed for breakfast and bought groceries. (Courtesy author.)

Ted Sliger has developed a historical hot-spring spa and motel off the Apache Trail, offering hot baths and various other mineral-water treatments. Ted discovered the mineral water accidentally in 1939. The Sligers had been operating a taxidermy shop when they dug a well to ensure a constant water supply, and to their surprise the water they hit when drilling the well was 112 degrees Fahrenheit. (Courtesy SMHS.)

Al Hutera (left) and Joe Grondick are among the few, but friendly, residents of Tortilla Flat. On April 21, 1987, a fire caused by leaking gasoline in the restaurant kitchen virtually destroyed Tortilla Flat. The owners immediately stated their determination that, like the phoenix, Tortilla Flat would rise from the ashes. (Courtesy SMHS.)

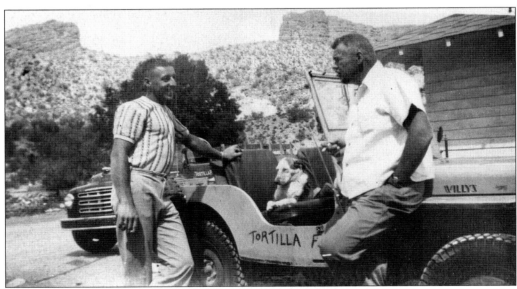

Joe Grondick (left) and Virgil Phelps visit with a friend. Shortly after World War II, Phelps and Joe Grondick and their wives purchased Tortilla Flat. They had many a distinguished guest, including Clark Gable, who liked to fish at Apache and Roosevelt Lakes. They built Tortilla Flat Motel, which they called their Gold Brick Court because they had made their brick from gold-mine tailings. In 1950, they sold Tortilla Flat to Jerry and Emily Stephens. (Courtesy SMHS.)

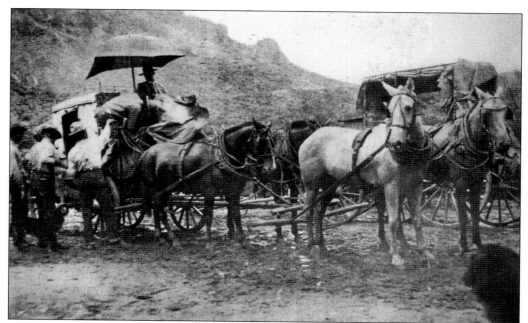

It was no easy task changing teams of horses at Tortilla Flat. By 1908, it had become a stage stop for changing teams when the stage traveled between Mesa and Globe, a 10-horse trip.

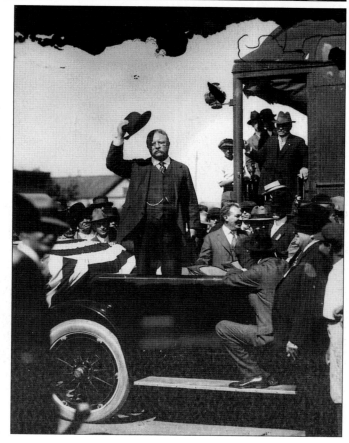

Former president Theodore Roosevelt greets the crowd as he leaves the train and gets in the car that will take him to the dedication ceremonies at Roosevelt Dam. The last car behind Roosevelt's entourage, number 13, contained mechanics with plenty of spare parts ready to make repairs if need the arose. When the automobile entourage arrived at Mormon Flat, the news was sent to the *Arizona Democrat* by carrier pigeon. (Courtesy Salt River Project.)

Louis C. Hill was the first engineer in charge of the Roosevelt Dam construction. On June 25, 1904, Benjamin Fowler, the first president of the association, and secretary of the interior Ethan A. Hitchcock signed the agreement between the Salt River Water Users' Association and the government. With the association in place, Hitchcock authorized the project on March 14, 1903. Once the torchlight parades and the congratulatory messages ended, the task of carving a dam out of rock began. In charge of the project were supervising engineer Louis C. Hill, chief engineer of the reclamation service Arthur Powell Davis, and design engineer Fred Teichman. Not only did supplies have to be brought in over the Apache Trail for the Roosevelt Dam construction, but the workers' personal effects had to be freighted in to the small community of Roosevelt as well. Common laborers of all types were paid $2 a day, drillers earned $2.75, carpenters $3.50 to $5, and sub-foremen $3.50. The government deducted 75¢ per day for meals. (Courtesy Salt River Project.)

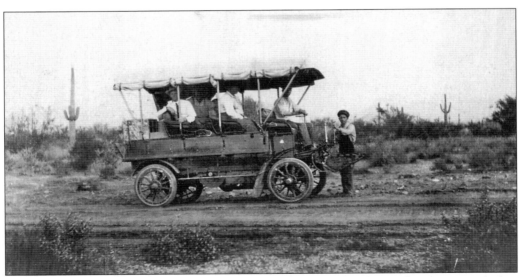

This automobile was used to cross the 23 miles of rough desert trails. Roads were so rough that one engineer remarked he had found several "excellent routes for airships." One road climbed toward Mesa on a 10-percent grade, for the most part along a vertical cliff several hundred feet high. In other places, rock cuts of 60 feet in depth were necessary. (Courtesy Arizona Historical Society.)

Entertainment seems to have been in very short supply, as these workers on the Roosevelt Reservoir are playing with a rattlesnake before killing it. (Courtesy Salt River Project.)

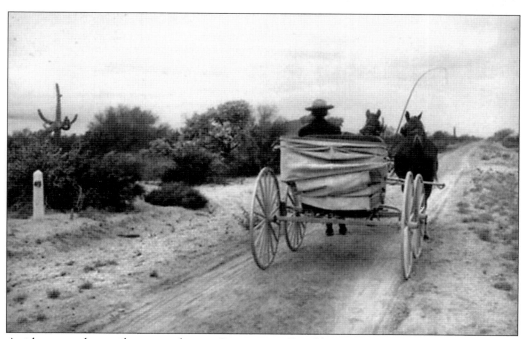

A rider passes by a milepost marker on Government Road between Desert Wells and Goldfield. Eight Mile Post is where the Roosevelt Stage would change horses. The road would go on past the Weekes' Ranch, where water was sold for "ten cents a span." (Courtesy SMHS.)

Tom Kollenborn retrieved milepost 23, on display at the Superstition Mountain Historical Museum. He recovered the perfectly preserved marker in 1973 while teaching a course on prospecting in the Superstitions for the Apache Junction Community College. (Courtesy SMHS.)

Workers are sacking cement for the dam. In early 1904, a sawmill 30 miles northeast of Roosevelt was completed with contract labor. A total of three million board feet of lumber was cut for use in everything from bridges to tunnel timbering and camp construction. A narrow-gauge railroad was built to carry limestone and clay for cement from the mountains above the dam site. The plant produced 338,500 barrels of cement. (Courtesy Salt River Project.)

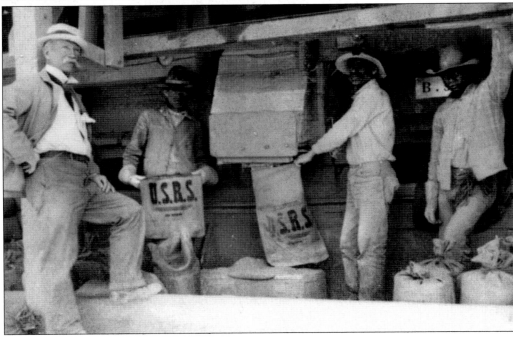

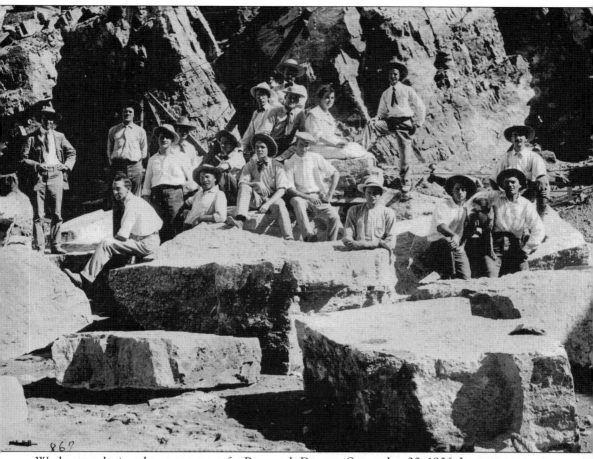

Workers are laying the cornerstone for Roosevelt Dam on September 30, 1906. It represents one of the last stone-masonry gravity dams built before concrete gravity structures dotted the West. It was designed with many modern features, including reinforced concrete pressure pipes, unique methods of laying masonry, and new kinds of hydraulic sluice gates, all of which made Roosevelt quite an aesthetic and engineering accomplishment. (Courtesy Salt River Project.)

Dwight Bancroft Heard's ranch, a showplace with purebred Herefords and Shorthorns, as well as thoroughbred horses, attracted many visitors, including Teddy Roosevelt. It was this association that helped get an act passed that facilitated the construction of Roosevelt Dam. Born into a wealthy Boston family, Heard moved to Phoenix and purchased 8,000 acres of land that today is the southern half of Phoenix. He also was publisher of the *Arizona Republican* newspaper and established the famous Heard Museum in Phoenix. (Courtesy Salt River Project.)

The last stone of Roosevelt Dam is being laid in 1911. (Courtesy Salt River Project.)

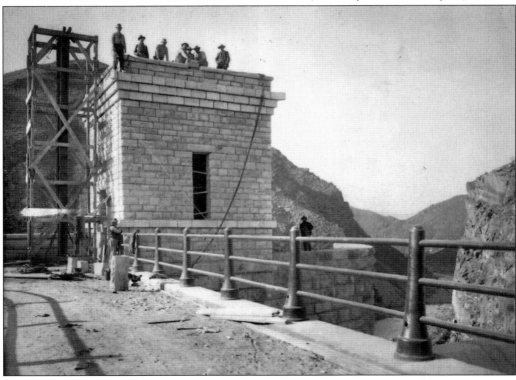

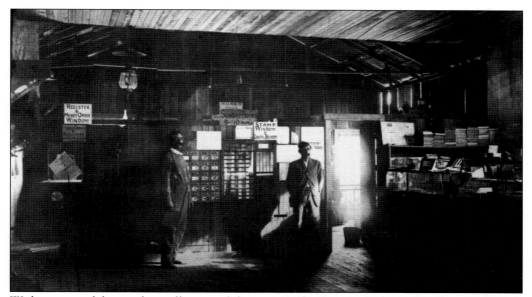

With so many laborers from all parts of the nation, the Roosevelt post office provided a link to home. The 400 residents of Roosevelt had access to a telephone line, three mercantiles, two restaurants, a jewelry and gun shop, a butcher shop, a bakery, two barbershops, a tent hospital, a septic tank to handle sewage, and a post office. The post office was established on January 22, 1904, with William A. Thompson serving as postmaster. (Courtesy Arizona Historical Society.)

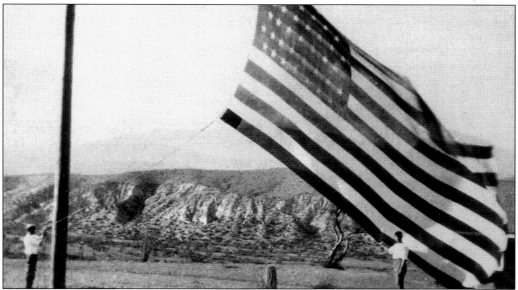

This large 40-star flag went up every morning at 8 a.m. and came down every evening at 5 p.m. during the construction of the dam. The flag is unique not only for its large size, but also for its number of stars. A 40-star flag would date to around 1889 when South Dakota was admitted to the Union. The official American flag went from 38 stars to 43 stars. Not many 40-star flags were created, which makes this example quite rare. During the construction of the Roosevelt Dam, Arizona was still a territory and was not represented by a star on the flag. (Courtesy Arizona Historical Society.)

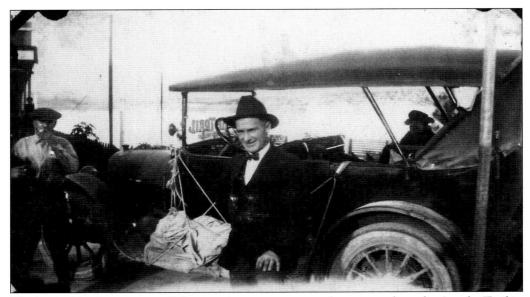

The horse-drawn stage was still the most important means of transport along the Apache Trail in 1905, but soon the automobile appeared on the scene. The Holdren Stage Line made daily trips to the Roosevelt Dam site, leaving Mesa at 6 a.m. and arriving at Roosevelt at 6 p.m. The Holdrens ordered an automobile to shorten the time between Mesa and Roosevelt, which they purchased from the Knox Automobile Company of Springfield, Massachusetts. It was a 20-horsepower vehicle that weighed 3,500 pounds and cost $3,000. It appears to have been the first automobile to operate on the Apache Trail, with its first trip taking place on August 25, 1905. The Knox automobile could travel between Mesa and Government Well in an hour and a half at a normal speed, which was an hour sooner than by stage and team. (Courtesy Arizona Historical Society.)

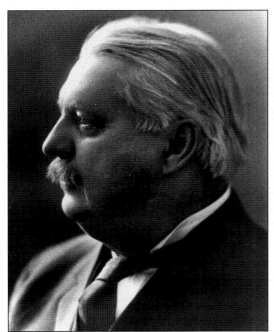

Joseph Henry Kibbey, born in Indiana on March 4, 1853, practiced law after being admitted to the Virginia State Bar until 1888, when he moved to Arizona for health reasons. In 1888, he was appointed as associate justice of the Arizona Territorial Supreme Court. He handed down the "Kibbey Decision," which dealt with land and water in Arizona and impacted the construction of the Roosevelt Dam. He was appointed territorial attorney general in November 1904, and when Governor Brodie retired, Kibbey replaced him. He promised to resign if Congress passed a bill that would have created statehood for Arizona and New Mexico to become one state. Eventually, the measure failed. Joseph Kibbey left office on May 1, 1909, but continued to serve as a counsel to the Salt River Valley Water User's Association and he drafted their articles of incorporation. (Courtesy Salt River Project.)

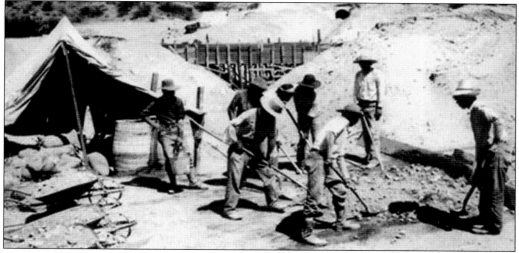

Apache workers mix cement for the cross-cut canal, a part of the Salt River Project. Apache workers played an important part in the construction of Roosevelt Dam, but their living quarters were kept segregated from the rest of the workers. Former scout Al Sieber directed the Native Americans. He was killed on February 19, 1907, when a large rock that was being moved by the Apaches fell and crushed him to death. (Courtesy Salt River Project.)

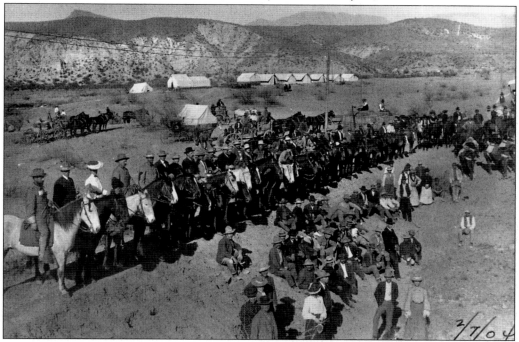

U.S. Reclamation Service engineers, laborers, and Roosevelt townsfolk gathered for a photograph on February 2, 1904. The year 1904 saw the end of controversy over the purchase of the dam site and the government filed a deed to the property with the county recorder on July 25, 1904. There were already murmurings of graft and corruption. By now, Roosevelt had a barbershop, a drugstore, two restaurants, and three general stores. Two doctors took care of the community, and dances were held on Saturday night at the town hall. (Courtesy Arizona Historical Society.)

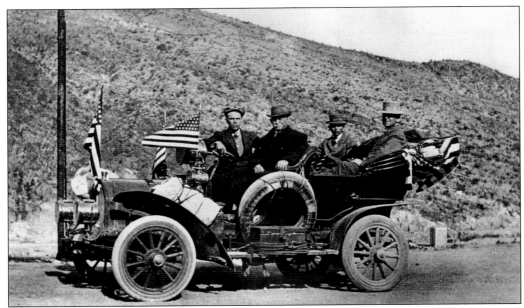

Many vehicles, festooned with flags of red, white, and blue bunting, made their way along the trail for the dedication ceremony. To accommodate visitors to Arizona's newest tourist attraction, a 16-foot-wide road for automobiles crossed the top of the dam. The succession of Theodore Roosevelt to the presidency in September 1901 supplied irrigation forces with a powerful ally. He loved the West, and supported of a national reclamation policy. The National Reclamation Act was passed into law on June 17, 1902. The act combined executive independence from Congress, nationalization, and a scientific approach to natural resource management. (Courtesy Salt River Project.)

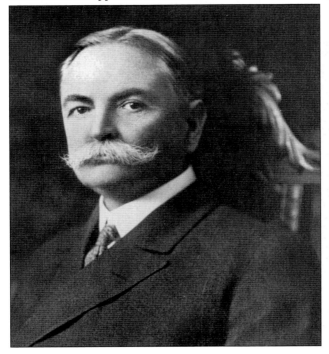

George H. Maxwell, a California water lawyer, became the leader of an alliance of business interests and advocates for federal irrigation projects throughout 16 Western states. He also bought a ranch in the area. Before the project was completed, he would be accused of improperly financial gains. A national movement was growing for federal financing of water reclamation projects. By 1901, Benjamin Fowler and Maxwell worked together with Rep. Francis G. Newlands of Nevada and Sen. Henry Hansbrough of North Dakota on legislation that would provide a way for local organizations in the West to borrow money from the federal government to build water storage and delivery projects. (Courtesy Salt River Project.)

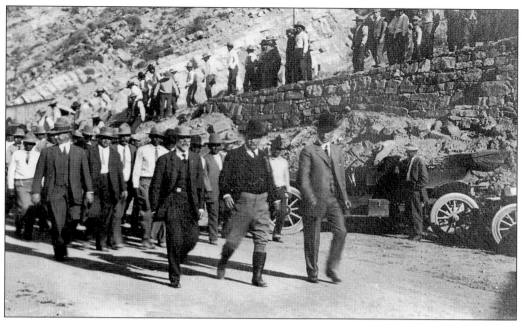

Teddy Roosevelt is escorted to the Roosevelt dam podium by dam engineer Louis C. Hill and judge Richard Sloane. (Courtesy Salt River Project.)

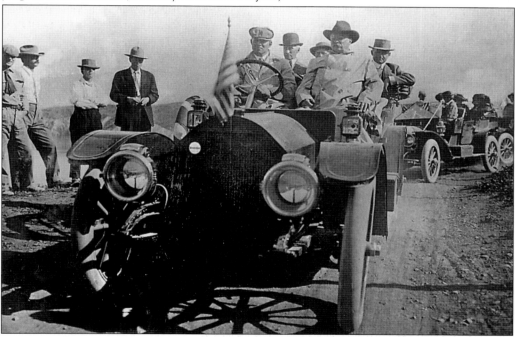

Teddy Roosevelt appears to be thoroughly enjoying his ride along the Apache Trail. Note that the steering wheel of the Kissel vehicle is on the right-hand side. His driver is Wesley A. Hill, a former Rough Rider who served under Roosevelt in Cuba. Along the way, Roosevelt was greeted by men and women in front of every farmhouse in the flat country and by miners in the canyon country. (Courtesy Salt River Project.)

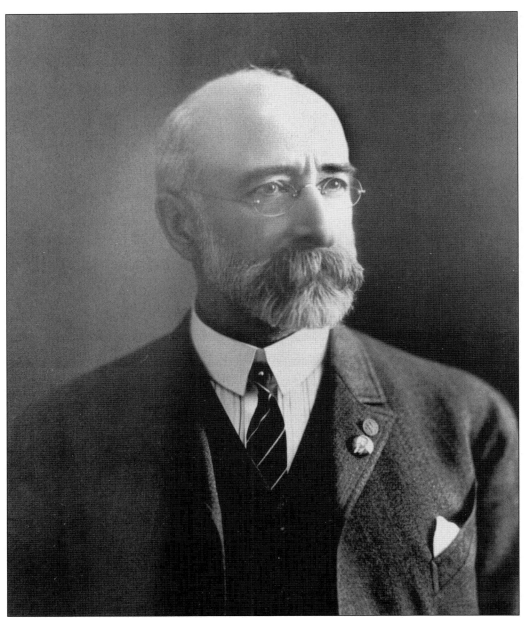

In the early 1900s, Arizona's struggle for a permanent water supply moved to Washington, D.C. Benjamin Fowler, chairman of the Maricopa County Water Storage Committee, visited the Capitol several times after 1900 and lobbied for passage of a bill that would permit the county to issue bonds for construction of a dam. Through the efforts of national reclamation lobbyist George Maxwell, Fowler, who later became the first president of the Salt River Valley Water Users' Association, met Frederick Newell and chief forester Gifford Pinchot. Fowler offered the U.S. Geological Survey $1,500 in matching funds to continue its investigation of the Salt River, including a survey of a dam site at the confluence of the Salt River and Tonto Creek. In Washington, D.C., Maxwell met with Newell, Fowler, and Pinchot to discuss the national irrigation movement and a possible Salt River Valley reclamation project. (Courtesy Salt River Project.)

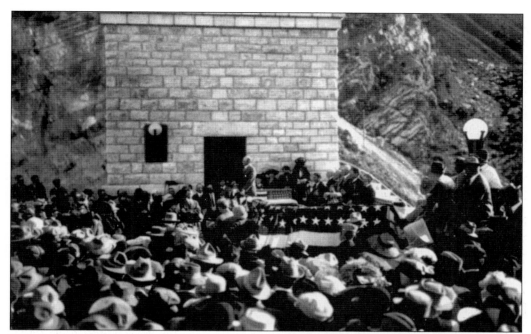

U.S. Bureau of Reclamation engineer Louis Hill, standing near the door, addresses the crowd. Hill said that even though the dam was only half full, the Water Users' Association was safe from drought for two years. Hill advised the crowd to think of the water in the reservoir as money in the bank, stating, "Conserve your water as the careful man does his bank account accumulated by years of self-denial." (Courtesy Salt River Project.)

Following the benediction by Rev. Julius Atwood, Roosevelt addressed the crowd and expressed great appreciation for naming the dam after him. He shared the podium with Gov. Richard Sloan, John Orme, the president of the Salt River Water Users' Association, Bishop Julius Atwood, Louis C. Hill, Ned Creighton, and Mark Dunbar. His final act was to press a button to allow a release of water from the reservoir and "a mighty roar of water rushed through the canyon and the dedication of the greatest storage dam and reservoir on earth was an accomplished feat." (Courtesy Salt River Project.)

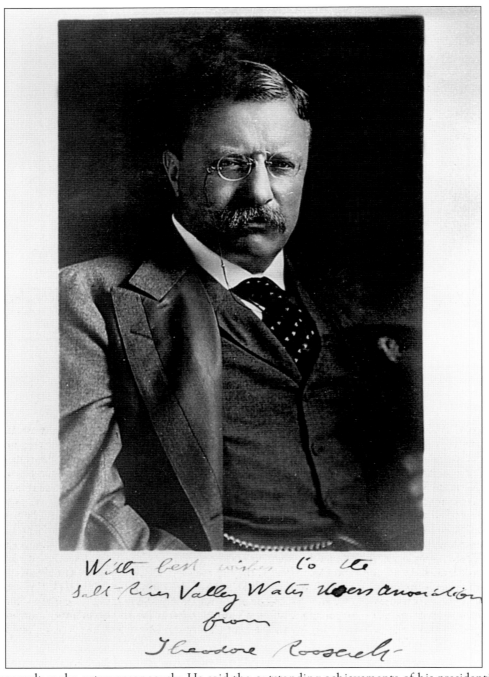

With best wishes to the Salt River Valley Water Users Association from Theodore Roosevelt

Roosevelt spoke extemporaneously. He said the outstanding achievements of his presidential administration were this reclamation work in the West and the Panama Canal. He said, "I do not know if it is of any consequence to a man whether he has a monument. I know it is of mighty little consequence whether he has a statue after he is dead. If there could be any monument that would appeal to any man, surely it is this." He presented the Salt River Water Users' Association with this autographed photograph. (Courtesy Salt River Project.)

114

Seven

THE SUPERSTITION
MOUNTAIN WILDERNESS

The year 1983 would change the Superstition Mountains forever. It was decided that it would be designated a wilderness area and forever closed to mining and prospecting except for the use of primitive tools. The department of agriculture placed a moratorium on claims in the Superstition Wilderness Area to mineral entry at midnight, December 31, 1983. This was to comply with the National Wilderness Act approved by Congress in 1964. February 14 became the deadline to stake claims in the Superstition Wilderness. On June 25, Superstition Mountain gold seekers were notified that they faced a December 31 closure date for all mineral entry. Each claim was investigated by a government appointed geologist who determined if the claim contained any commercial grade ore. If not it was terminated with no compensation. Consequently since it was a government employee, no commercial grade ore was found and all claims were terminated within the wilderness. At midnight on December 31, the Superstition Wilderness area was closed to all mining except under the most stringent conditions. Now the thunder gods are really laughing, because their secret has been made safe by the government. For the dreamers, here are some of the most important maps purporting to show where the mine is located. Remember, numerous prospectors have claimed that they found the Lost Dutchman Mine. It is just that no one has ever found the gold.

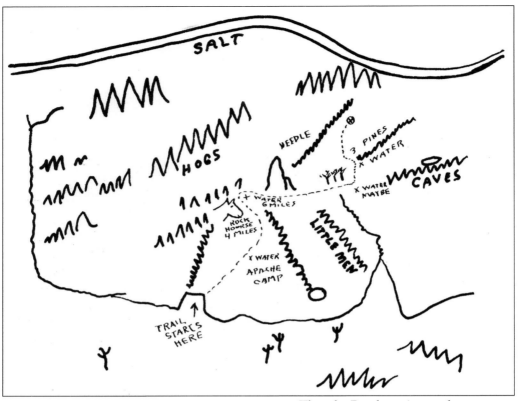

This, the Dutchman's map, first appeared in print in 1938 in the Sunday supplement known as the *Family Circle*, with an article on the legend of the Lost Dutchman Mine by Oren Arnold. There are several variations of this map, and it may be the one that Julia Thomas copied and sold around Phoenix. She claimed it was the one that Jacob Waltz drew up for her just before his death in 1891. (Courtesy SMHS.)

The Ruth/Gonzalez map, also known as the Peralta/Ruth map or the *perfil* or profile map according to Erwin Ruth, was one several given to him by the Gonzalez family when he helped members of the clan get into the United States. Erwin claimed that this is the one his father Adolph Ruth carried when he was murdered in the Superstition Mountains in 1931. (Courtesy SMHS.)

The late Frank L. Fish claimed that a mining engineer in Mexico told him about this treasure map, which supposedly shows a valuable gold deposit in the Superstition Mountains. He also said that he found members of the Peralta family and that this mine came from Manuel Peralta. (Courtesy SMHS.)

The Minas Del Oro (mines of gold) map was part of the collection of John S. Burbridge. It also came from the Gonzales family, who claimed to be related to the Peraltas. They suggest that it shows the location of family mining properties in the Superstition Mountains. (Courtesy SMHS.)

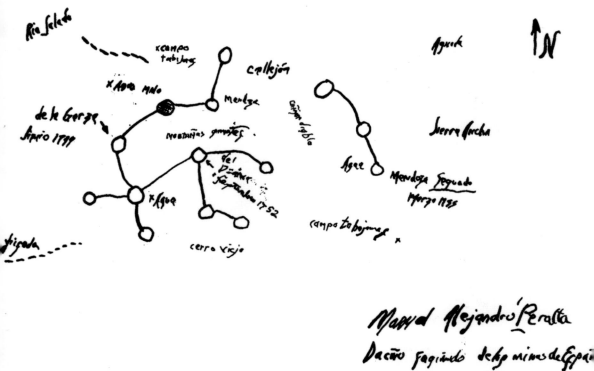

The Manuel Peralta map first appeared in an article by John S. Burbridge in *Treasure Hunter Magazine* in 1972. Burbridge gave it to Barry Storm for interpretation. It supposedly shows the Peralta family's buried treasure. (Courtesy SMHS.)

The Wagoner map was first published in Barry Storm's book *Thunder Gods Gold* in 1946. A man known only as Wagoner often rode a stagecoach driven by Fred Mullins from Pinal. On his last trip, he gave Mullins this map that showed his gold mine in the Superstition Mountains. (Courtesy SMHS.)

The Gonzalez Mexican Mine was drawn up by Barry Storm, based on clues from people who claimed to have seen the original. One day, a man rode into Maricopa Wells in the 1870s where he met Charles M. Clark. He said he was looking for a lost mine in the Superstition Mountains. Clark loaned Gonzalez horses and supplies and in return he gave Clark a copy of this map. (Courtesy SMHS.)

Eight

THE SUPERSTITION MOUNTAIN HISTORICAL SOCIETY

On December 27, 1979, the Superstition Mountain Historical Society was formed. The first temporary board was established in January 1980. A year later, its first quarterly journal was published, and in 1984, the society began printing annual journals. The society has amassed a large collection of memorabilia, artifacts, and minerals. It acquired a large collection of mining ore cars and Phelps Dodge donated 60 tons of historic mining equipment, including several train engines. A display case, manufactured in Chicago in 1894, had been installed in the first Goldwater store in Prescott.

A monument of a prospector and his burro commemorates the story of the Lost Dutchman Mine and Superstition Mountain. It was planned by a committee of men who were searching for a community project for the Phoenix Dons' Club in 1937. James A. Murphy, Louis C. Tisdale, Rhes Cornelius, and George C. Curtis came up with an idea. The Dons liked Fred Guirey's proposed sketch of the monument and approved a budget of $150 for its construction. Constructed in the shape of a stone wall, the monument is about 8 feet high, 12 feet long, and 2 feet wide and was surmounted with a cut-out figure of a prospector and his burro. Set in the wall is a bronze plaque bearing the legend of the Lost Dutchman Mine. Construction required the cooperation of the Arizona Highway Department, the Salt River Water Users Association, the Phoenix Dons' Club, and the Phoenix Brick Mason's Union. The land was donated by George C. Curtis. Monument construction was completed on February 25, 1938, and it was dedicated on April 8, 1938. James A. Murphy, president of the Phoenix Dons Club, gave the dedicatory address and presented the monument to the people of the state of Arizona.

The Superstition Mountain Museum collects, preserves, and displays the artifacts, history, and folklore of the Superstition Mountains, Apache Junction, and the surrounding region. The 160,000-acre Superstition Mountain range is full of legend and history. Superstition Mountain and the Lost Dutchman Mine are synonymous with Arizona lore. Many of the Superstition Mountain Historical Society exhibits focus on mining, but this one provides a history of Arizona's mounted military. (Courtesy author.)

Books on the history, legends, and lore of the Superstition Mountain area, as well as Native American crafts and jewelry, are available at the Superstition Mountain Historical Museum. (Courtesy SMHS.)

What would a bar be without an old-time piano? (Courtesy author.)

The post office kept isolated communities in touch with the rest of the country. (Courtesy author.)

The gift shop offers Native American arts and crafts from the southwestern pueblos, including Acoma, Jemez, and Santo Domingo. The designs are both traditional and modern. (Courtesy SMHS.)

Animals native to the Superstition Mountains include bobcats, mountain lions, whitetail and mule deer, javelinas, porcupines, coyotes, ringtail cats, jackrabbits, desert cottontails, Gila monsters, several species of squirrels, chipmunks, and bats, four species of skunks, over a dozen snake species, and more than 100 species of birds. (Courtesy author.)

Clay Worst, Shirley Keeton, and George Johnston present Gov. Janet Napolitano with Kokopelli artwork and a plaque commemorating her visit. She also received a lifetime membership in the historical society. (Photograph by Macomber; courtesy SMHS.)

Governor Napolitano, Wanderer the mule, Teton Ken Eddy, and District Two supervisor of Pinal County Sandi Smith enjoy a lighthearted moment. (Photograph by Larew; courtesy SMHS.)

Every year, Apache junction celebrates Lost Dutchman Days, and the rodeo is an important part of the festivities. (Courtesy Apache Junction Chamber of Commerce.)

For the less intrepid, the Lost Dutchman Days provide rides and activities for the family. (Courtesy Apache Junction Chamber of Commerce.)

The Elvis Presley Chapel was donated to the Superstition Mountain Historical Society by Ed and Sue Birmingham. It was part of Apacheland, a movie location built in 1959 for the film studios. Ronald Reagan filmed *Death Valley Days*, one of the first made-for-television films, there. Elvis Presley came and filmed the movie *El Charro* at Apacheland, and the church was one of the famous scenes in the movie. He also stayed at the Superstition Grand Hotel in Apache Junction during filming. Ever since Elvis filmed the movie with the church, it has been known as the Elvis Presley Memorial Chapel. (Courtesy SMHS.)

The miner, ever the dreamer, continues his quest for gold. (Courtesy SMHS.)

ACROSS AMERICA, PEOPLE ARE DISCOVERING SOMETHING WONDERFUL. *THEIR HERITAGE.*

Arcadia Publishing is the leading local history publisher in the United States. With more than 3,000 titles in print and hundreds of new titles released every year, Arcadia has extensive specialized experience chronicling the history of communities and celebrating America's hidden stories, bringing to life the people, places, and events from the past. To discover the history of other communities across the nation, please visit:

www.arcadiapublishing.com

Customized search tools allow you to find regional history books about the town where you grew up, the cities where your friends and family live, the town where your parents met, or even that retirement spot you've been dreaming about.